FILL YOUR WATERCOLORS WITH NATURE'S LIGHT

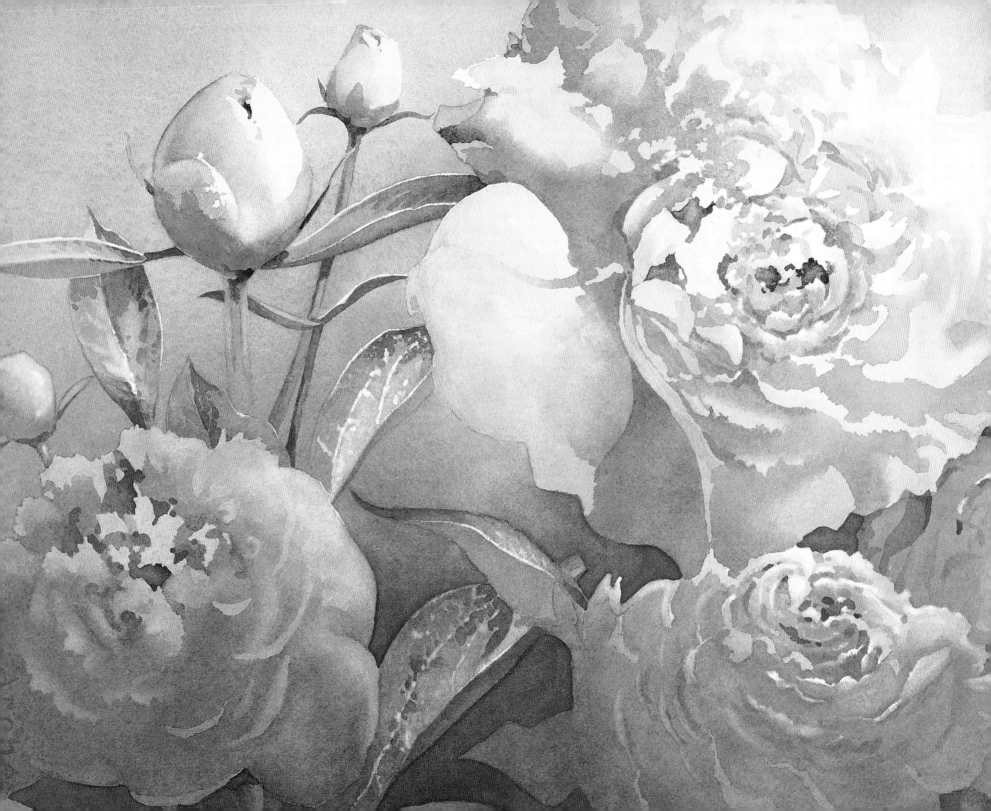

Fill Your Watercolors with
nature's
Light

Roland Roycraft

NORTH LIGHT BOOKS
CINCINNATI, OHIO
WWW.ARTISTSNETWORK.COM

05 04 03 02 01 5 4 3 2 1

Library of Congress Cataloging-in-Publication Data

Roycraft, Roland.
 Fill your watercolors with nature's light / by Roland Roycraft.
 p. cm.
 Includes index.
 ISBN 1-58180-039-8 (alk. paper)
 1. Watercolor painting—Technique. 2. Landscape painting—Technique. 3. Flowers in art. I. Title.

ND2240 .R814 2001
751.42'2436—dc21 00-068109
 CIP

Editor: Stefanie Laufersweiler
Designer: Wendy Dunning
Interior production artist: Joni DeLuca
Production coordinator: Sara Dumford

Upon graduating from high school in Duluth, Minnesota, Roland Roycraft studied for two years under a local commercial artist before going to Chicago. There he graduated from the American Academy of Art in 1941 with an Associate in Technology degree with a major in graphic arts. He then spent four years as a tool and die engineer during World War II before returning to the academy to study watercolor under Herb Olsen.

Roland spent the following thirty-five years as a commercial artist, art director and advertising manager, with his work appearing in national publications such as *Saturday Evening Post*, *Better Homes and Gardens*, *Life* and *Look*. He also designed the dust jackets for the re-issue of eleven *Wizard of Oz* books before retiring to Beulah, Michigan. Roland began teaching watercolor locally, which laid the foundation for his first book, *Fill Your Watercolors With Light and Color* (North Light Books, 1990). That best-selling book made him known internationally, and students have traveled from all over the world to workshops he has conducted throughout the United States. When Fox Animations was formed in 1995 in Phoenix, Arizona, Roland was asked to teach their animators his theory of light and color for use in the film *Anastasia*.

Roland's paintings have appeared in many other books, including the cover of *Painting the Effects of Weather* (North Light Books, 1992). He is a signature member of the American Watercolor Society and the Midwest Watercolor Society.

METRIC CONVERSION CHART		
to convert	**to**	**multiply by**
Inches	Centimeters	2.54
Centimeters	Inches	0.4
Feet	Centimeters	30.5
Centimeters	Feet	0.03
Yards	Meters	0.9
Meters	Yards	1.1
Sq. Inches	Sq. Centimeters	6.45
Sq. Centimeters	Sq. Inches	0.16
Sq. Feet	Sq. Meters	0.09
Sq. Meters	Sq. Feet	10.8
Sq. Yards	Sq. Meters	0.8
Sq. Meters	Sq. Yards	1.2
Pounds	Kilograms	0.45
Kilograms	Pounds	2.2
Ounces	Grams	28.4
Grams	Ounces	0.04

Acknowledgments

I want to thank the many students who have come from all over the world to share this great adventure. Each one has added something to the overall experience we have shared. Terry Trumble and Jackie Trimble provided the inspiration for the classroom chapter with the photos they took during the workshops they attended. Others have introduced me to new tools to create special effects. We all learn from each other.

I want to add a word of appreciation to my wife, Dorothy, for her counseling during this writing process, and to my editor, Stefanie Laufersweiler, and the crew at North Light for the opportunity to express my ideas in print. 彩

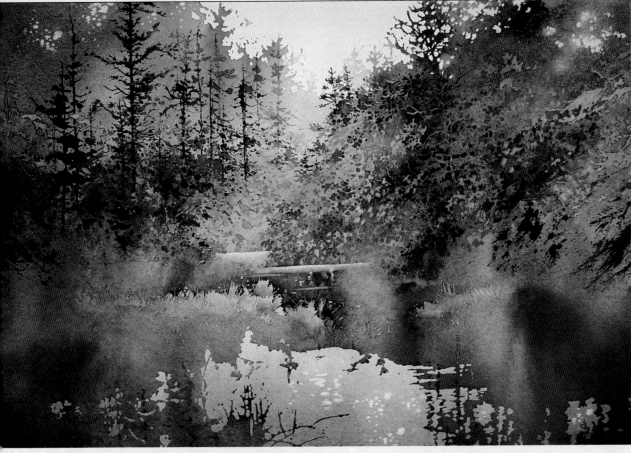

CRYSTAL REFLECTIONS
14" x 21" (36cm x 53cm)

This book is the culmination of over sixty years of commercial art, fine art painting and teaching. The first years taught me the disciplines and skills necessary to be professional, but the relationships generated through teaching have been the most rewarding of all. The student questions that arose provoked me into finding answers and new ways to explain my theories of color, composition and methods of expression. It was through these workshops that I first met Henry Malouf from Sydney, Australia. He is the owner of a large retail and wholesale art supply business there. In his own words, this is how we became friends:

"As a large reseller of art books, I was very excited when Roland's first book, *Fill Your Watercolors With Light and Color*, was shown to me. Most of the other books in stock were still rehashing how to paint landscapes, trees or other objects. I could read them in a single night without learning anything new. Most kept 90 percent of their secrets to themselves.

For years I had struggled with how to paint light. I loved his work so much I had to contact him and learn how to do this work. Since then, I have traveled to the United States four times to attend his workshops, which I have thoroughly enjoyed. He creates excitement with his pupils and teaches with no secrets withheld. I have learned something different in each workshop, as he is always experimenting with new ideas and ways to create enthusiasm.

Roland's new concepts of composition and flower painting are unique and gave us all a lot of pleasure in trying these new skills. I hope you will have as much fun with this new book as thousands of readers have had with his first book." ❧

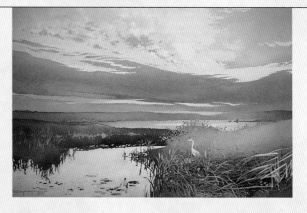

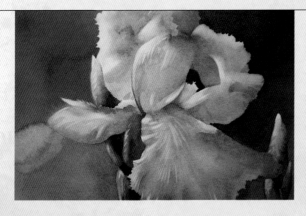

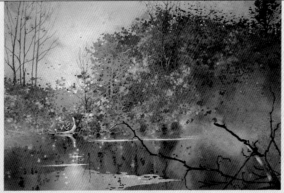

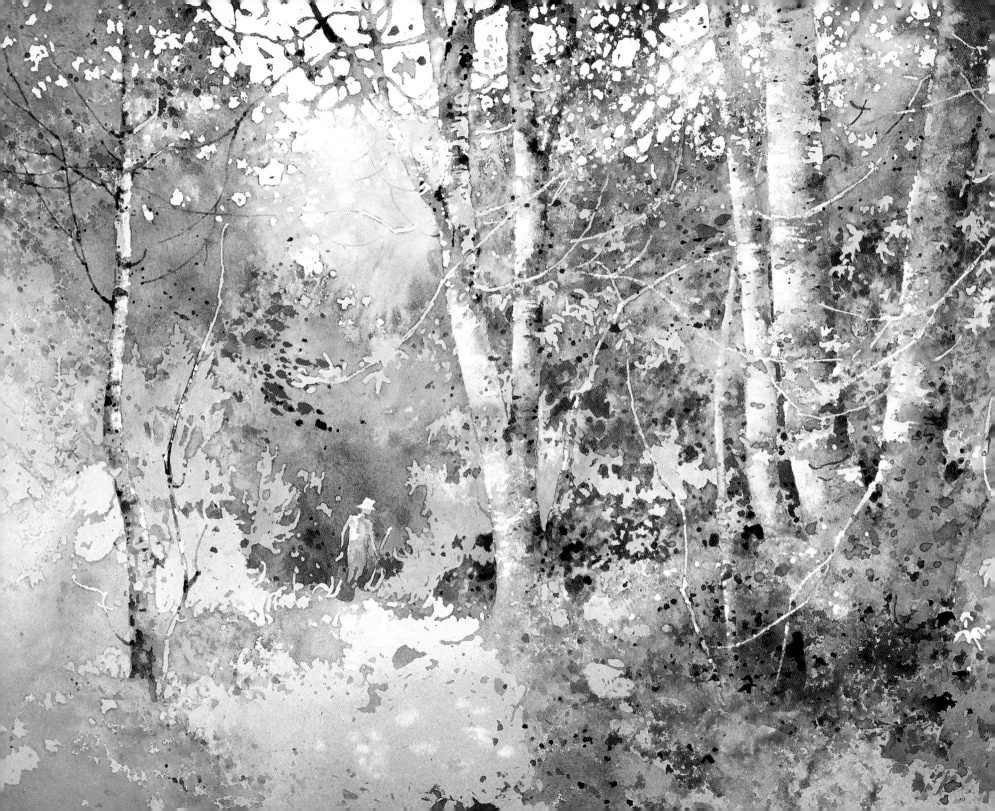

One of the first things I ask my students to do is evaluate themselves to find out who they are. How do you see things? Are you neat and tidy, or do you see things in a wild and wacky way? Are you a careful planner, or do you just go for it? These are the types of questions you must answer to determine the type of painter you will be.

Who am I? I consider myself an abstract painter who leans toward realism. I don't understand complicated things, so I have to simplify everything in order to understand it. That's how I came to develop a method of composition that has been proven in my workshops. The theories I have developed have come over a period of years as a result of this frustration.

Also, I don't believe in telling everything in my paintings, which makes me somewhat of an impressionist. The viewer must fill in the missing parts. I create an illusion or mystery that is meant to provoke people and make them wish they were at that place too. I exaggerate and distort things in order to design elements that get along with each other. This is what makes my paintings mine. This is what you must do, too.

I will guide you through a simplified system of composition, color application and self-evaluation to enable you to climb to a higher step in your interpretation of painting landscapes and flowers. I will try to stimulate thought and cause you to see life beyond all its natural beauty, beyond the obvious. But most of all, this is a learning adventure where light is the principal player in this intriguing game we call art.

The last few years of teaching transparent watercolor have been a great source of inspiration, searching and experimentation for me.

Inspiration comes to us from the enthusiasm to learn when venturing into unchartered waters.

Searching is the process of trying to find answers to old problems, and defining ways to explain new theories.

Experimentation leads us to innovative ways to compose and apply color in a less controlled and mechanical manner. This is what the creative process is all about.

In this book, I will give you the tools to work with and guide you through the many stages of painting a transparent watercolor. It doesn't come all at once. After being involved in art and painting all my life, I am still learning just like you. So let's go for it! ❧

FALL BIRCH
14" x 21" (36cm x 53cm)

Studio Suggestions and Materials

In every workshop I suggest that everyone who is able stand while pouring, spattering or laying in the initial portions of any painting. The reason is that you need to be able to move freely and react to the free-flow of paint as it is applied. Otherwise, the painting gets mechanical and lifeless. Consequently, my working surfaces are all high enough so that I don't have to stoop too far.

I use a high swivel stool to sit on while applying masking and painting final details. I even stand to sketch in the initial shapes and sizes that make up the composition. To me, this is very important for a spontaneous result.

Here are the materials you'll need to get started.

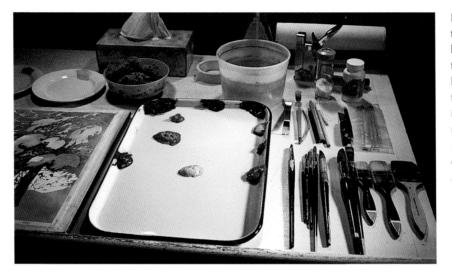

My general studio setup is in the shape of a U. My paints, brushes and other tools are to the right side of my work, and less-frequently used items are to the left side. I work standing up so I have freedom to move around. I sit only when I am applying masking or doing detail at the finish of a painting.

Paper
I use Arches 140-lb. (300gsm) cold-press paper most of the time for several reasons. It has a tough, absorbent surface that withstands a lot of abuse in lifting paint and applying masking. The absorbent quality allows pouring over previously painted areas without washing off. Also, the weight dries more readily than heavier weights to shorten drying time. Occasionally I use 300-lb. (640gsm) on full-sheet paintings when I need the paper to stay moist for an extended period of time while I'm lifting paint. (This is done in the chapter on flowers.) Once in a while I use illustration board because of its hard surface, which allows the paint to sit on top and act in a more lively manner. However, you can't pour over a painted surface without washing it off. Also, if you work too wet, the board may delaminate.

Palette
I use a large butcher's tray for general mixing plus two white plastic saucers for pouring Winsor Lemon and Winsor Red. These two atmospheric primaries must be kept pure and free from contamination of other paints to achieve clean results in the pouring period.

Colors
The colors on my palette are Winsor Lemon, Winsor Red, Cobalt Blue, Aureolin, Cadmium Scarlet, Antwerp Blue, Brown Madder, Cerulean Blue, French Ultramarine and Payne's Gray. Occasionally I will use Raw Sienna, Burnt Sienna and Sepia from another palette to save time in mixing for small paintings in which time is critical.

Brushes
I have an assortment of round sable brushes from no. 2 to no. 10, flat brushes from a half-inch to three inches (12mm to 76mm), filbert brushes nos. 8 and 12 and Chinese hakes, plus several large, round natural hair brushes (no. 22 or larger) for throwing paint. A stiff toothbrush and various sizes of Fritch scrubbers are necessary for scrubbing out paint.

Other Tools
A mat knife, palette knife and single-edge razor blades are useful for applying paint or scraping. A water jar, a spray bottle for spritzing and tissues are absolutely necessary. Other items you'll need are: a ⅜-inch-thick (95mm) plywood board for mounting paper, a staple gun and staple remover, a 4B pencil, art gum, an electric eraser, masking solution (I use

White Mask), a length of hemp rope for applying masking, rubber cement pickup for masking removal, and sponges. Stencil material and a stencil burner are next to necessary. An Incredible Nib is invaluable for lifting small areas of paint. And, most of all, the desire to learn and the patience to persevere are also required.

Above is one wall of my gallery located at my home in Beulah, Michigan. I have elected to sell through my own gallery, because the artist and his work are inseparable. Each painting has a story behind it that personalizes it for the viewer and makes it more meaningful.

PROTECT YOUR BACKBOARD AND PAINTING WITH HOUSEPAINT

I paint all my plywood backboards with white housepaint (latex or oil) to keep them from soaking up the moisture from wet paper. It also keeps the acid content in the wood from discoloring the back of the paper. If you are interested in preservation, be aware that this acid stain could work its way through the paper over time.

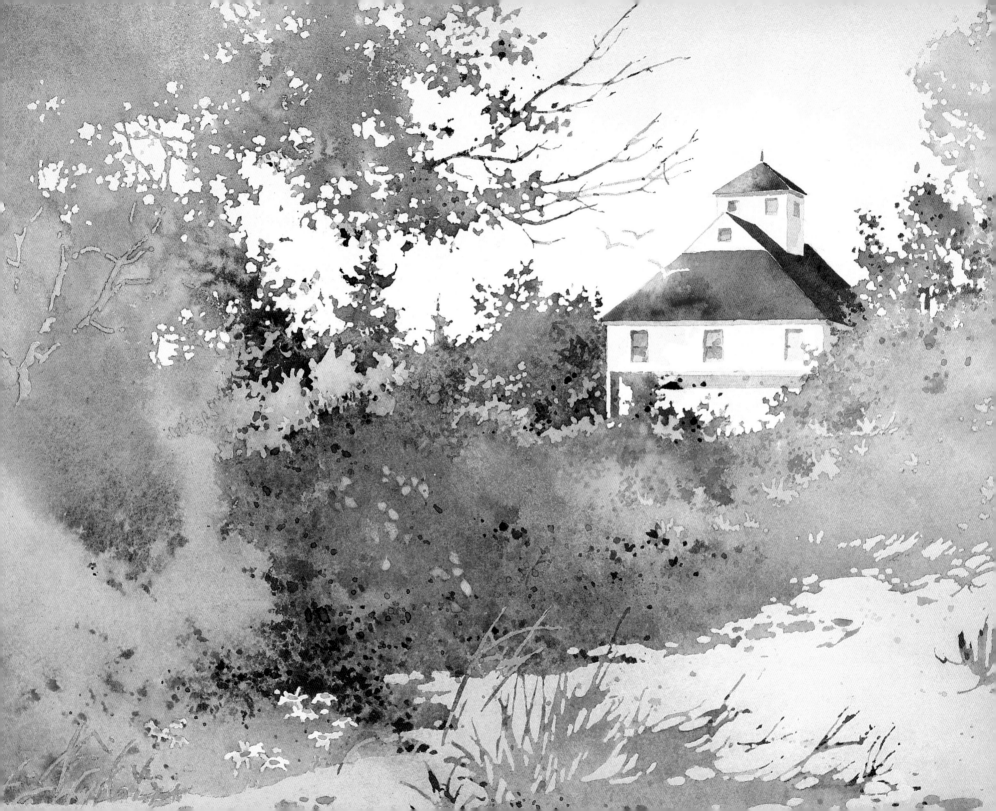

Chapter One

the Basic Principles
of Landscape Painting

SUMMER GETAWAY
14" x 21" (36cm x 53cm)

Three Theories for Landscapes

When I first started landscape painting, I was generally confused with the intricacy of the scenes I was looking at. The myriad details overwhelmed me and left me not knowing where to start. It was only by stepping back and carefully analyzing what I saw that I noticed the abstract patterns that tied everything together. In order to explain these patterns and the breakup of space to the students in the first classes I held in my studio, I devised terminology to simplify their early efforts. The following theories are the three basic principles I use to paint landscapes.

Bar Theory

I created the *bar theory* to explain the primary breakup of space and tonal values in a landscape. The source of light, or sky, is the lightest area with a value from 0 to 30 percent. The ground, which receives the light, is the middle value of 30 to 60 percent. The vertical portions in shade—including vegetation, trees and buildings—are in the darkest area of 60 to 90 percent. With a snowy winter scene or bright sand on a beach, the bar theory sketch is turned upside down as the sky is usually darker than the ground in these settings.

This first step in designing the composition of your painting should emphasize the unequal shapes and sizes of these various value areas so they are interesting to look at. Sometimes, several thumbnail sketches are required to finalize the pattern you are satisfied with. A painting may include one, two or all three horizontal bars.

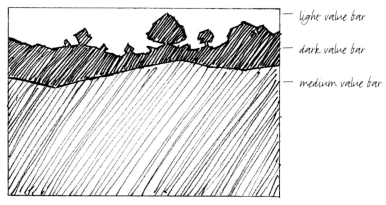

light value bar
dark value bar
medium value bar

This thumbnail sketch illustrates the tonal values and divisions of space for my painting *One on the Rocks*.

Notice how the elements of this painting are divided according to the bar theory: The sky is in light value, the trees are in dark value and the rocks are in medium value. The unequal divisions make for a better composition.

ONE ON THE ROCKS
14" x 21" (36cm x 53cm)

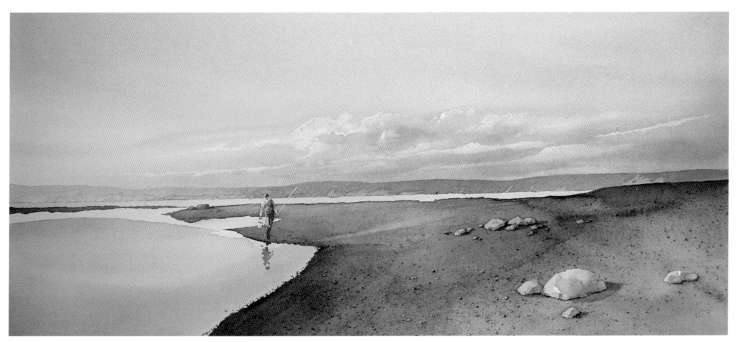

The sky and clouds make up the lightest (and biggest) value bar of this painting. There is no dark value bar, as the only vertical object is the figure. The challenge was to get sufficient texture in the foreground beach sand to help lead the eye back into the composition. Vary the value bar sizes and shapes to make your paintings more interesting.

PLATTE BAY
14" x 29" (36cm x 74cm)

Action Line

Because the horizon line used in one- or two-point perspective is seldom seen, the silhouette of the foreground against the sky or background is what I call the *action line*. It can involve the lacework of the painting as it includes all the little holes between the branches, foliage and sky. I try to get at least a small part of the action line in every painting because it helps to indicate a source of light.

A secondary action line, which is less important, may serve as a divider between the two lower value bars. If a reflective surface such as water is in the foreground, an upside-down action line may appear there in the sky and background reflections.

Several thumbnail sketches should be made to experiment with this preliminary division of space. The action line is part of the bar theory.

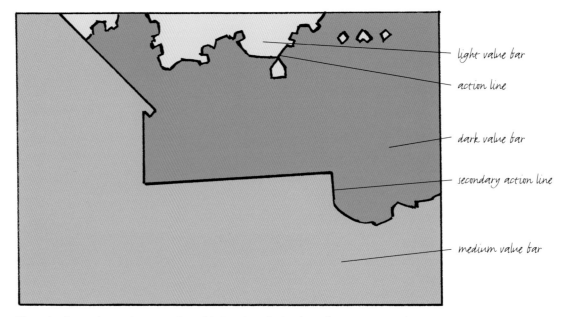

light value bar

action line

dark value bar

secondary action line

medium value bar

The action line and secondary action line of *At Rest* show the breakup of space in its simplest form. The action lines clearly mark the value divisions of the painting.

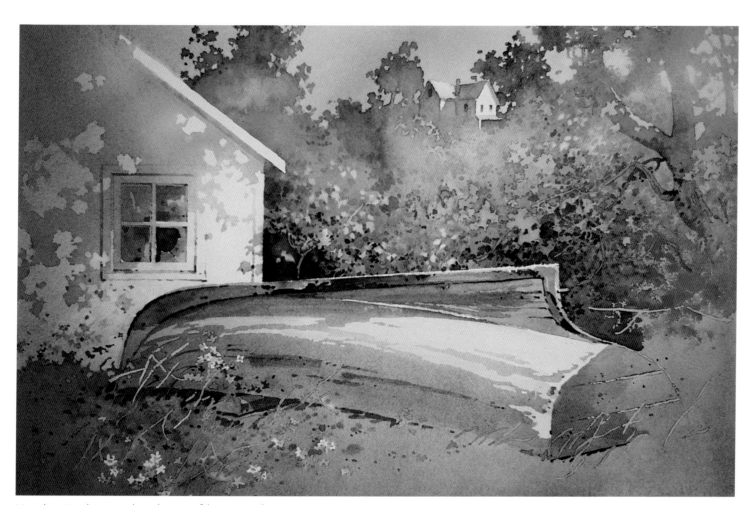

Here the action line runs along the tops of the trees, and includes the lacework of the trees. The secondary action line runs along the house and the overturned boat. These action lines add movement to the composition.

AT REST
14" x 21" (36cm x 53cm)

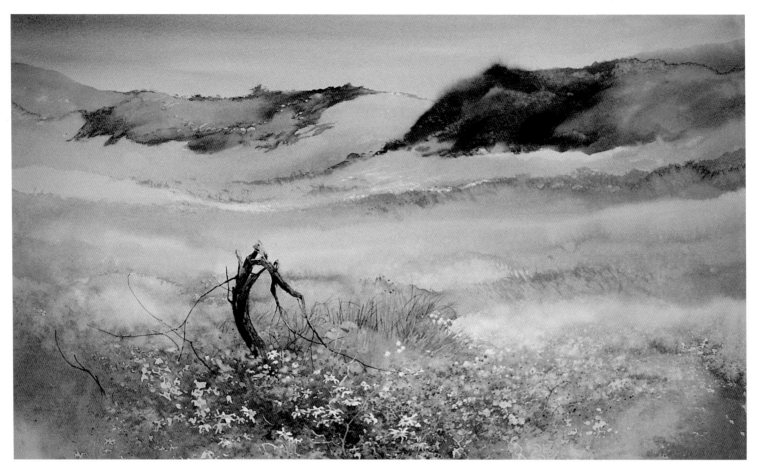

Here's another example of the bar theory at work. Emphasis is on the foreground here, which is dominated by wildflowers.

SLEEPING BEAR
18" x 29" (46cm x 74cm)
Collection of David and Karen Remington

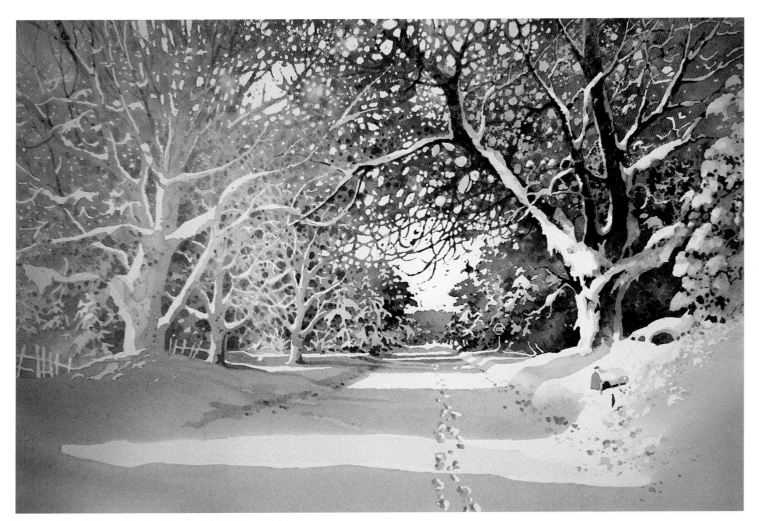

The action line in this painting involves the intricate lacework in the bare treetops. The perspective of the street area, plus the sky opening at the end of the street where the darker values are, draw the viewer's eye right into the painting.

CENTER STREET
14" x 21" (36cm x 53cm)
Collection of Mary Peterson

Fragmentation and Diagramming

Fragmentation and diagramming a painting with composition chips is the biggest breakthrough I've encountered in trying to teach composition in my workshops. I used to do this breakup of space intuitively, but found it hard to teach to others. Now, I diagram everything before I begin a painting.

Fragmentation

The breakup of space in the largest bar of a landscape painting into smaller segments is called *fragmentation*. In order to avoid the pitfalls of following a poor photograph, I encourage you to try this exercise. Cut up one of your small throw-away paintings into various small pieces and put them into an envelope. Sketch a rectangle onto a white piece of paper, and shake some of these composition chips, as I call them, onto the area. This forms a random pattern of small groupings of various shapes, sizes and colors.

Reposition some of the pieces to your satisfaction. This random dropping is a way of imitating nature's way of dividing up space. The chips could represent a cluster of leaves in the woods, a group of people in the mall or clouds in the sky.

Now, let's see how a representational painting looks using this principle.

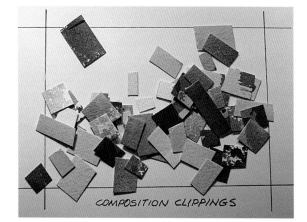

COMPOSITION CLIPPINGS

Pictured are the composition chips I dropped onto a piece of mat board to get a sense of the shapes and colors I wanted to use for *Fragmented Light*. Keep in mind the relationships between the negative and positive shapes and sizes. The chips may need some adjusting with a finger. The colored chips transformed into sparkling jewels in my mind as I envisioned the sun coming through the glistening winter foliage.

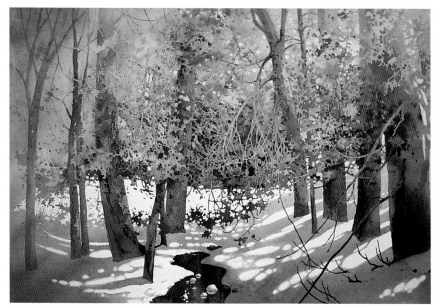

The multicolored background of *Fragmented Light* illustrates the fragmentation of the winter woods as the light filters through the branches and dried vegetation. A three-dimensional effect is created by these small fragments of complementary colors. Notice how a normally drab scene comes to life.

FRAGMENTED LIGHT
14" x 21" (36cm x 53cm)
Collection of William Jamnick

Bits and Pieces

Now, let's use the chips in their natural abstract form and add the silhouette shapes of tubes of paint, paint brushes, a pencil, drops of paint and clippings from an art materials sale flyer. This adds a touch of realism and forms the foundation for *Bits and Pieces*. This simple beginning during a watercolor workshop started a revolution for my students in understanding composition. It has helped me in evaluating my own work and with my experiments.

HOW TO POUR

First, wet your paper, which should be attached to a backboard, with a spray bottle, pouring off the excess moisture. Then dilute your pouring colors in individual white saucers, and pour them on the wet paper one at a time. The paint mixture you pour must be at least twice as dark as you want it to be since it will be further diluted on the wet surface.

Yellow represents light and always comes first, red next as it is transitional, and blue last as it represents shadows.

Tilt the board and use your spray bottle to help direct the color. Let the excess color run off the paper to avoid watermarks. If your first pourings seem too weak, you can repeat this process, but the fewer the layers, the better your painting will look.

When you are finished you can use a hair dryer to speed up the drying process. Be sure to let each layer dry *before* moving on to the next one.

Photo by Terry Trumble

1 TRACE CHIPS AND APPLY MASKING
Drop chips on a half-sheet of cold-press paper and trace around them with a pencil. Add silhouettes of various art materials to give it a semblance of reality. (I also traced words from a flyer.) Apply masking to the entire background around the chips and silhouettes.

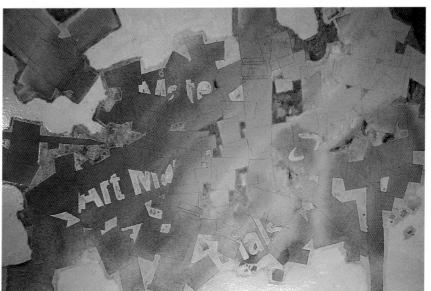

2 POUR COLORS
Pour the atmospheric colors of Winsor Lemon, Winsor Red and Cobalt Blue in that order, allowing the paint to dry completely between each color. Pour each color from a different location to avoid neutralizing the others. This provides the color key for the entire painting.

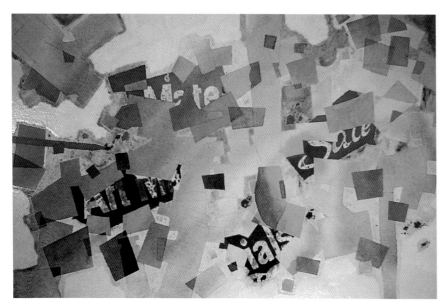

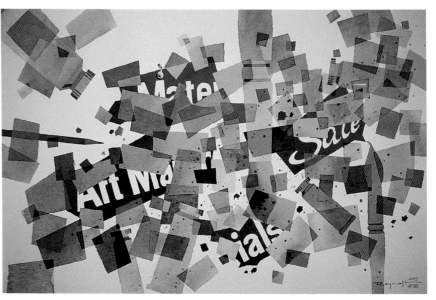

3 STRENGTHEN VALUES
Designate a specific color for each area following the hues formed by the pouring. Where the chips overlap, strengthen the values.

4 REMOVE MASKING AND FINISH
Remove all masking and strengthen overlapped portions even more to finish the painting.

BITS AND PIECES
14" x 21" (36cm x 53cm)

Diagramming

Diagramming takes fragmentation one step further. The abstract shapes created by the arrangement of composition chips are converted to actual realistic elements of a painting. This is the stage when the parts and working relationships of the various elements are established, whether they appear abstract or real.

As composition chips of different sizes and shapes are dropped, each chip represents anything you want it to be. They could be clouds, clumps of snow, people, flowers, stones or whatever you want in a given breakup of space in your bar theory.

Whether choosing your subject from real life or photographs, I recommend that you always diagram the elements that make up a scene. This will make the painting process easier.

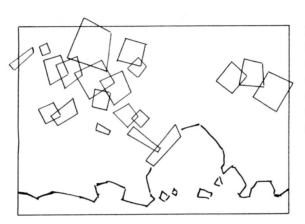

In diagramming *The Tempest*, the large sky area was fragmented by the dropping of composition chips and then converted to softer shapes to make clouds for the finished painting.

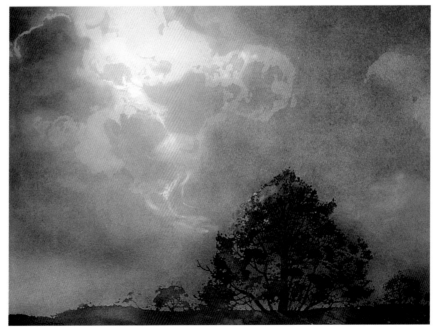

In converting the abstract shapes of the clouds in *The Tempest* to realistic ones, I merely rounded off their corners. Here the abstract forms easily indicate the relationship between one cloud segment and the next.

THE TEMPEST
21" x 29" (53cm x 74cm)

single leaf

small group of
leaves or larger
leaf in foreground

large group of leaves or
huge leaf in foreground

In some cases, the abstract forms of the composition chips are harder to visualize or interpret. In *Strike*, the geometric forms basically represent a group of leaves of a given value, and need to be converted into real shapes within the shape of the chip. A small chip may represent a single leaf, whereas a larger chip could be a group of leaves.

The foreground clumps of leaves in the painting are a result of dropping the composition chips to form these random patterns. The artist has to be careful to not let any area appear uniform in the breakup of space. The amount of space should vary between each clump. Compare the diagram to the finished painting.

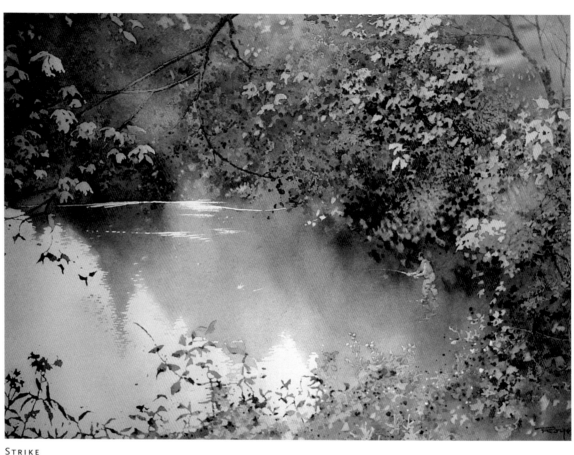

STRIKE
14" x 21" (36cm x 53cm)
Collection of John and Judy Desenberg

demonstration
House on 669

Let's take the theories we've just learned and apply them in a practical demonstration of how they all go together. *House on 669* has a unique history that sets the tone for the area in which I live and paint. It was built in 1874 by Cyrus Meabon. He and his family came by covered wagon to northern Michigan from Erie, Pennsylvania, with his sister Jane and her husband. They had acquired over 280 acres of land through the Homestead Act of 1862 and carried the homestead certificate signed by President Ulysses S. Grant.

This primitive log cabin, a landmark that has since been torn down, was typical of the times. Sister Jane planted the silver maple tree which you can see in my photo as the large dead tree to the right of the cabin. This subject is a perfect example to illustrate the three basic principles.

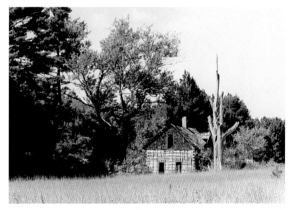 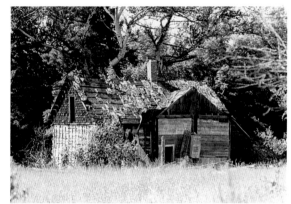

These photos were the basis from which the diagramming and finished painting were made.

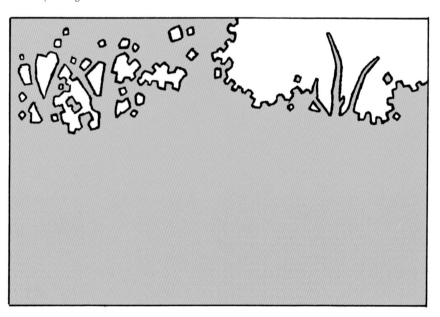

1 DETERMINE ACTION LINE

The first step in planning any painting is to determine the action line. Here, it runs along the treetops and includes spaces between some of the foliage.

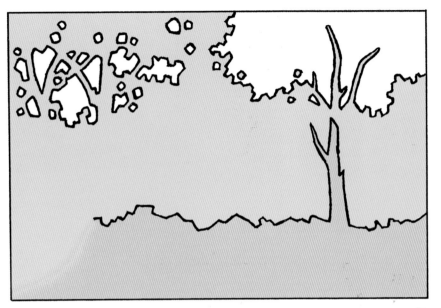

2 ADD SECONDARY ACTION LINE
The secondary action line, located along the ground and part of the dead tree, is added to further break up space and form the three divisions of the bar theory.

3 PLACE THE HOUSE
The geometric, light areas of the house—its side, part of the roof and the chimney—are added.

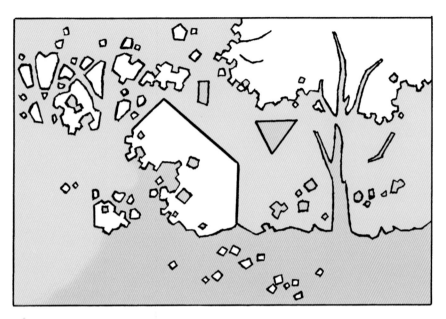

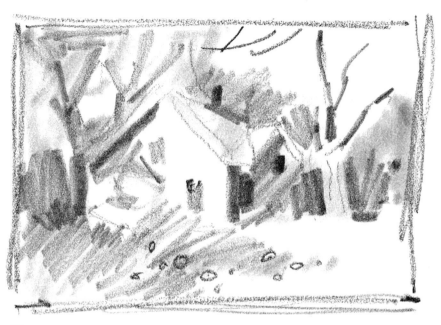

4 DROP COMPOSITION CHIPS
Composition chips are dropped to form the shadows on the house plus the flowers in the foreground.

5 MAKE A THUMBNAIL
A pencil thumbnail is made to determine the value pattern of the finished painting.

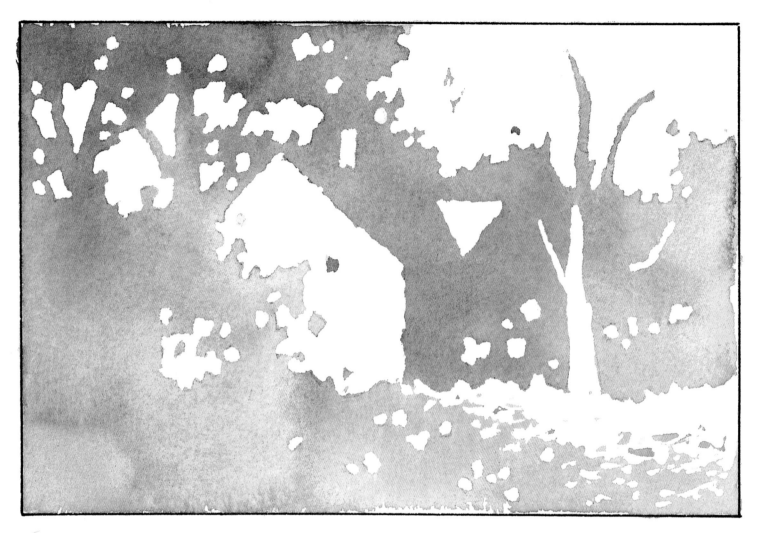

6 MAKE A COLOR THUMBNAIL FOR COLOR SCHEME

The color scheme is determined by making a color thumbnail. I masked out the lightest areas and loosely painted in an atmospheric underpainting. I then removed the masking and had my basis for the finished painting.

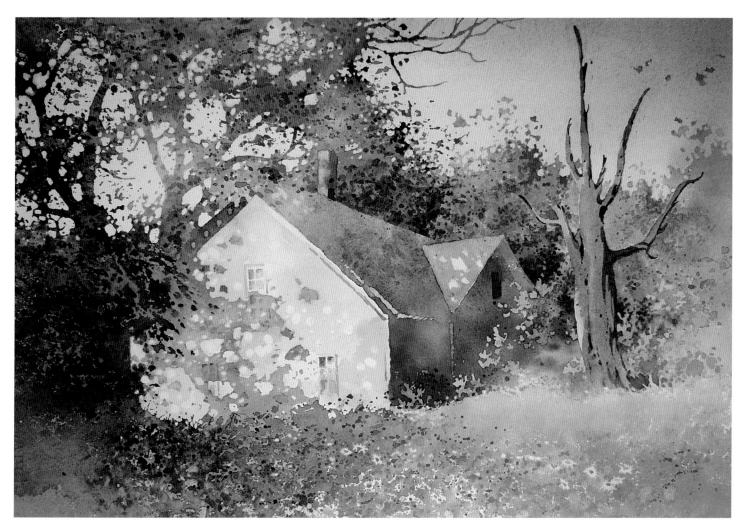

FINISHED PAINTING

Although the original subject was a log cabin, I didn't want to complicate the painting by having that much detail to compete with the foliage and shadow patterns.

HOUSE ON 669
14" x 21" (36cm x 53cm)

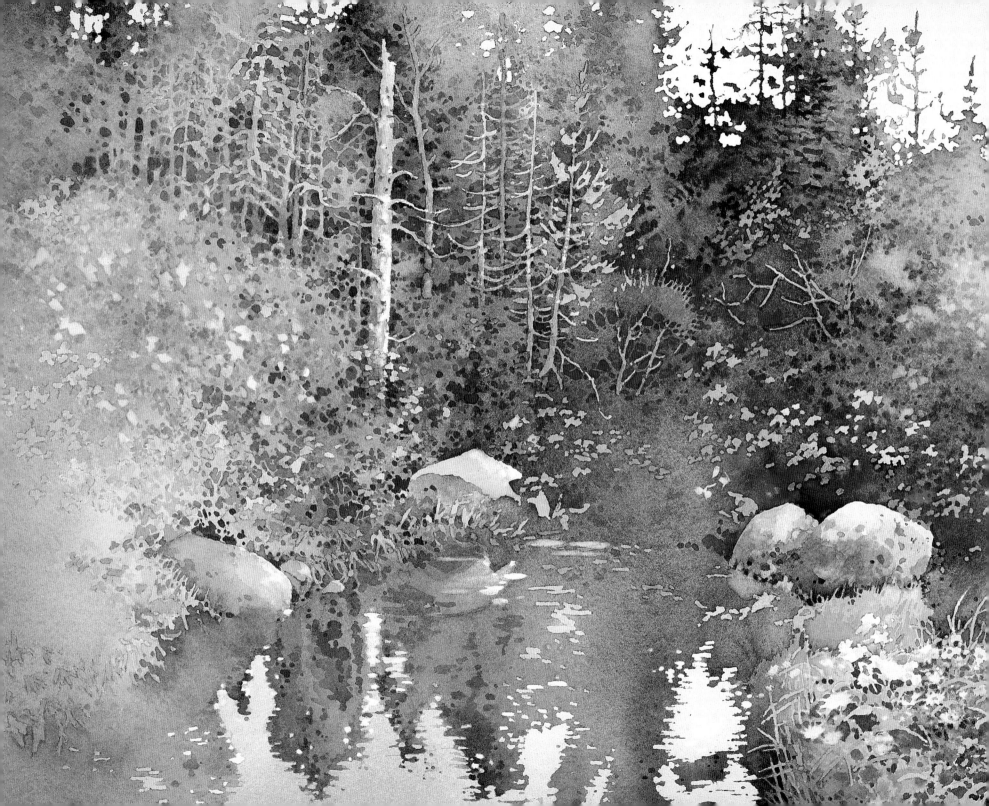

Seven Simple Elements
to Structure Your Painting

CHANGING SEASONS
14" x 21" (36cm x 53cm)
Collection of Shirley and Adam Zutaut

Use Atmospheric Colors and Constructive Colors

element 1

Color is a word that is all-inclusive. The primary colors—red, yellow and blue—are the colors from which all others are derived. Each primary color has a warm side and a cool side. The temperature within each color distinguishes its main purpose in painting.

When teaching, I have found that I've had to make this distinction between colors and primaries to define the correct use for each. Students have asked me how red and yellow can be termed cool colors. The answer is that they aren't cool colors, but they can be cool primaries. Both cool primaries and warm primaries are used to complete a painting.

WHEN TO USE WHICH COLORS

◆ *Winsor Lemon, Winsor Red and Cobalt Blue*—to pour on the atmosphere
◆ *Aureolin, Cadmium Scarlet and Antwerp Blue*—for spattering on texture
◆ *Various blues and sometimes Payne's Gray*—to create various combinations for pouring blues
◆ *Payne's Gray and French Ultramarine*—for darkening when mixed with other colors
◆ *Cerulean Blue*—to brighten cool shadows or soften the harshness of French Ultramarine

Atmospheric colors are the cool primaries of Winsor Lemon, Winsor Red and Cobalt Blue. They define the source of light, shadows, mood, weather or other atmospheric elements including snow, ice and reflections in water. They set the stage and dictate the color selections for the rest of the painting. They are very transparent in character. For example, a cool red over a cool yellow makes a cool secondary color with an orange tint. Similarly, Cobalt Blue over Winsor Lemon makes a greenish tint.

Constructive colors are the warm primaries of Aureolin, Cadmium Scarlet and Antwerp Blue. These colors are more heavily pigmented and are used in the spattering process for texture of rocks, leaves, flowers and other vegetation.

These warm and cool primaries are only part of the color spectrum. In addition, I use Brown Madder, French Ultramarine, Cerulean Blue and occasionally Payne's Gray to fill out my complete palette. All colors on the palette are used to finish the details.

I always start a painting at the light source, using the cool Winsor Lemon. As I change colors to keep from getting monotonous, I have only two choices: I can lean to the cool blue side making a pale greenish color, or I can go to the cool red side, creating a pale orange. There is always a relationship between the color changes as I proceed in a painting.

tip **USE A BUTCHER'S TRAY FOR A PALETTE**

Using a butcher's tray for a palette makes the mixing of colors so much easier, especially when working with bigger brushes. Prop up the top part of the tray with a block of wood so the palette will drain excess color to the bottom and not dilute the freshly squeezed paint. Place your colors at the top and middle of the tray. (See the palette setup on the next page.) This leaves the bottom portion for mixing and excess runoff.

If you have one of the newer trays with a hump in the middle, be sure to place the freshly squeezed paint on the hump so the water from the brush, when mixing paint, drains off to the side and down to the bottom. Otherwise the paint will be sitting in a pool of water. I prefer to let freshly squeezed paint dry for about two days before painting to avoid picking up juicy color on the brush and transferring it to the watercolor paper before it is thoroughly mixed.

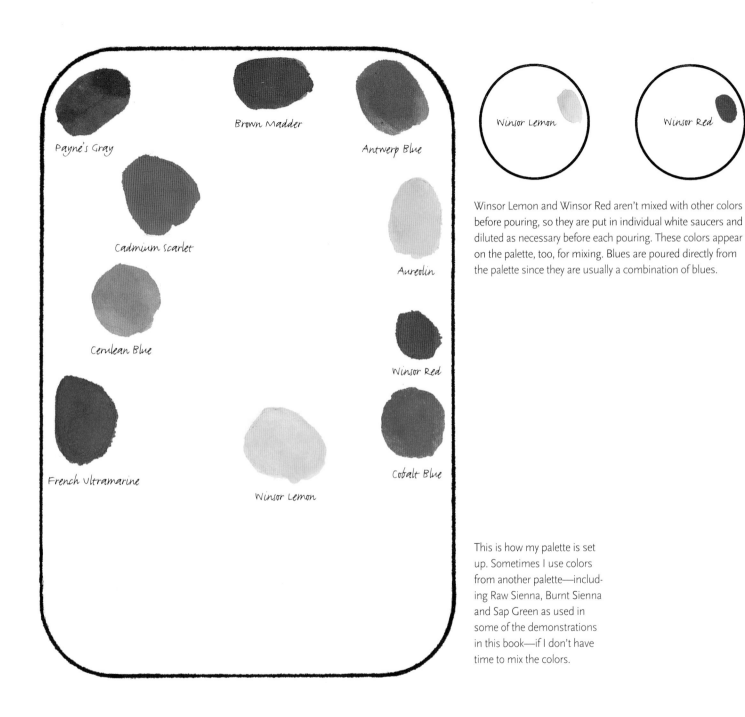

Payne's Gray

Brown Madder

Antwerp Blue

Cadmium Scarlet

Aureolin

Cerulean Blue

Winsor Red

French Ultramarine

Winsor Lemon

Cobalt Blue

Winsor Lemon

Winsor Red

Winsor Lemon and Winsor Red aren't mixed with other colors before pouring, so they are put in individual white saucers and diluted as necessary before each pouring. These colors appear on the palette, too, for mixing. Blues are poured directly from the palette since they are usually a combination of blues.

This is how my palette is set up. Sometimes I use colors from another palette—including Raw Sienna, Burnt Sienna and Sap Green as used in some of the demonstrations in this book—if I don't have time to mix the colors.

Recognize Space

Space is defined as the distance, expanse or area between, over or within things; the area or its equivalent left vacant by things. In other words, any object you see is termed a positive shape. The space around the object is called negative space. This is where the term negative/positive painting comes from.

Being conscious of space while painting is the hardest thing for the beginning artist to comprehend. Our whole learning experience teaches us only to observe things, not the space around them. For that reason, negative/positive exercises are very useful to remind one of the total experience.

Basically, there are three ways to preserve the positive image from the negative background: masking, painting around and wiping out. These methods are just as important as the application of paint, and each technique has its advantages and disadvantages.

Masking

Masking involves using material such as tape or masking fluid to protect an area of paper from being painted. The masking will divert the paint and result in interesting patterns during the pouring process. These uncontrolled happenings are what make each painting unique.

Masking produces a hard edge when removed, and works best when this is the quality you desire.

Hard edges can be softened by lifting paint with a wet brush and clean water and then blotting with a tissue.

I use masking to silhouette the background from the sky, and for defining areas in the foreground that would otherwise get lost in my wild application of paint. In applying the masking, I try to create a complete overall design. I think of it in terms of making a wood block print—the masking is like cutting away the wood so it doesn't print. This stage of initial preparation is vital to the final outcome of your painting.

Painting Around

Painting around an area, or negative painting, works well when painting large objects such as a snowy foreground, or when detail isn't too intricate. It allows the artist to soften any given edge in the process of painting to make it look less mechanical. In painting trees in a forest, the artist has to be conscious of the light source, knowing whether the trees are lighter or darker than the background. Also, the background may vary in value. The tree would then be painted dark where the background is light, and light where the background is dark. Always think light against dark and dark against light. These contrasts are what make a painting exciting.

Wiping Out

This approach to painting is just the opposite of traditional methods. Instead of applying paint to portray your subject, you remove paint from a wet background of color. It also teaches us to see shapes and broad concepts instead of details.

Wiping out paint from a dark background produces a slightly soft edge and makes for a nice combination when used with masking, especially where complicated leaf structures are needed to give a three-dimensional look.

This can be done several ways. For skies, the wet paint can be blotted with a tissue to form clouds. In smaller areas, paint that has already dried can be rewet with a dampened brush or Incredible Nib and blotted with a tissue. A Fritch scrubber is a special synthetic brush with a slight abrasive action specifically made for the removal of paint. It comes in five different sizes in flat, and three different sizes in round. Stencils can also be cut to control the area to be scrubbed. (See "How to Cut a Stencil" on page 43.)

Whatever the tool, clean water is necessary and you may need to repeat scrubbing or blotting several times to lift the right amount of paint.

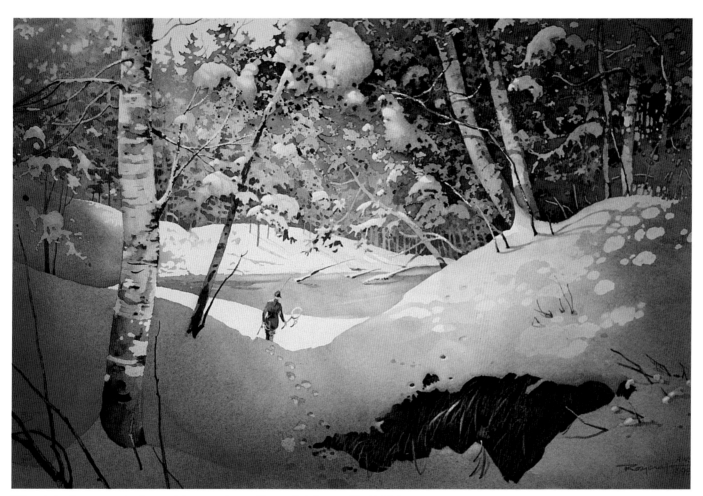

This painting is an example of recognizing space by masking and wiping out. The highlights on the foreground snow were masked, as well as the sky, snow clumps in the background and the birch trees. The dark shadow on the foreground snow was poured on, and highlights on the grasses where the spring water flows were wiped out.

BELOW THE HOMESTEAD DAM

14" x 21" (36cm x 53cm)

Huddled Together

demonstration

After a heavy snowfall one winter, my blue spruce trees by the road were laden with heavy clumps of snow. I quickly diagrammed the clumps for shapes and sizes and then transposed the diagram into a realistic thumbnail sketch for my value pattern. This was the basis for *Huddled Together*, a painting in which masking is used.

Diagram of snow clumps and highlights on snow for *Huddled Together*.

The thumbnail shows the transition from the abstract to the realistic.

1 MAKE SKETCH AND APPLY MASKING

Make a sketch on a quarter sheet of watercolor paper to indicate the areas that need to be masked. Apply masking to the snow clumps and the sun streaks on the ground so the background can be freely painted. (I used White Mask tinted with non-staining watercolor.) Keep in mind that masking needs to be thinned with water so it applies without globbing up. Apply liberally so it will peel off easily when dry. Notice how the masking creates a pattern of its own.

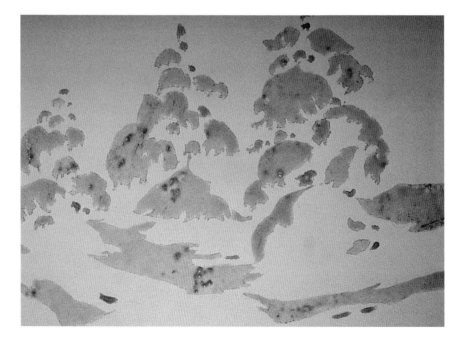

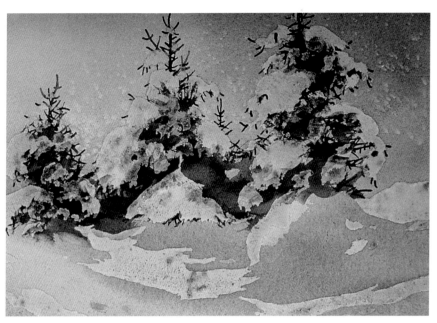

2 BEGIN PAINTING AND MAKE SNOWFLAKES
Paint the medium-value sky and snow shadows wet-in-wet with various blues and touches of Brown Madder and Winsor Lemon to take off the edge. Tilt the board to allow mixing of the colors on the paper. Sprinkle salt on your paper while it is still wet. Let the paper dry, and when you brush off the salt, snowflakes will remain.

3 PAINT THE TREES
Add the spruce trees next, painting around the masked snow clumps and keeping in mind that the branches grow in fan patterns. Use combinations of Antwerp Blue, Aureolin and a little Brown Madder, and vary the proportions of warm primaries so the tree color is not the same all over. Avoid excess detail in the shadow areas. Let dry.

tip **DON'T USE A BRUSH FOR MASKING**

To avoid ruining good brushes with masking fluid, I use a sharpened twig to apply the masking on the small details, and a length of hemp rope attached to a brush handle to apply on larger areas. When finished, clip off the used end of the hemp rope, and you have a brand new "brush" for the next time.

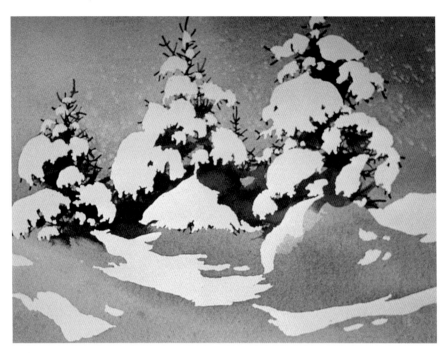

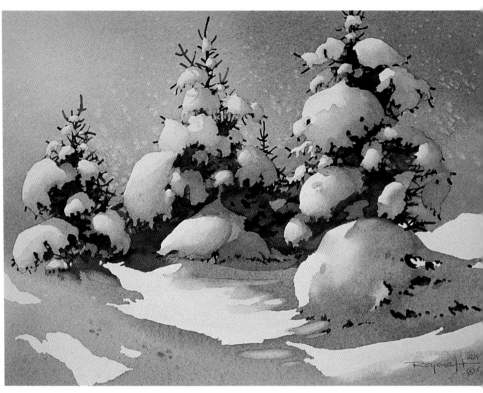

4 REMOVE MASKING
Remove the masking with a rubber cement pickup.

5 ADD SHADOWS AND FINISH DETAILS
Add shadows to the snow clumps, keeping in mind the direction of the light source. Start with Cobalt Blue, and add a touch of Winsor Lemon near the light source and some French Ultramarine in the darker areas. Soften some shadows in the foreground where the masking has been removed with a Fritch scrubber to give a more natural look. Finish other details as necessary; I added more detail to the bottom part of the tree on the far right.

HUDDLED TOGETHER
10" x 14" (25cm x 36cm)
Collection of Fred Trimble

tip SOFTENING HARD EDGES

To soften a hard edge created by masking, moisten your Fritch scrubber in clean water and gently agitate the edge, then blot with a tissue. Work on one small area at a time, and repeat until you get the softness you're happy with.

Fat Tuesday

This scene of my backyard illustrates both negative and positive painting. It keeps the large background from becoming monotonous and also adds depth. Negative painting is the hardest thing for the blossoming artist to understand because we are brought up to see positive things rather than the space around objects.

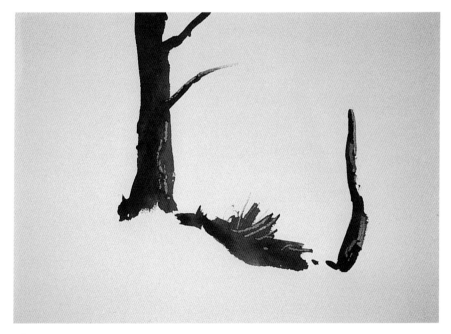

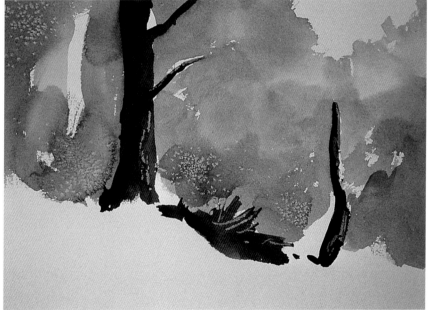

1 PAINT TREE TRUNKS AND PATCH OF GROUND

On a quarter sheet of watercolor paper, paint a tree trunk, a patch of bare ground and a stump using Brown Madder, Antwerp Blue and Cadmium Scarlet. Scrape on bark texture with a dull knife. Let dry.

2 BEGIN BACKGROUND

Using the cool atmospheric primaries, roughly paint in a background around the positive trees, leaving some snow clumps, a piece of open sky and part of a birch tree trunk on the left. Don't be too careful, as accidents such as blobs and watermarks are an asset at this stage. Add a few sprinkles of salt for snowflakes. After the paper is dry, brush away the salt.

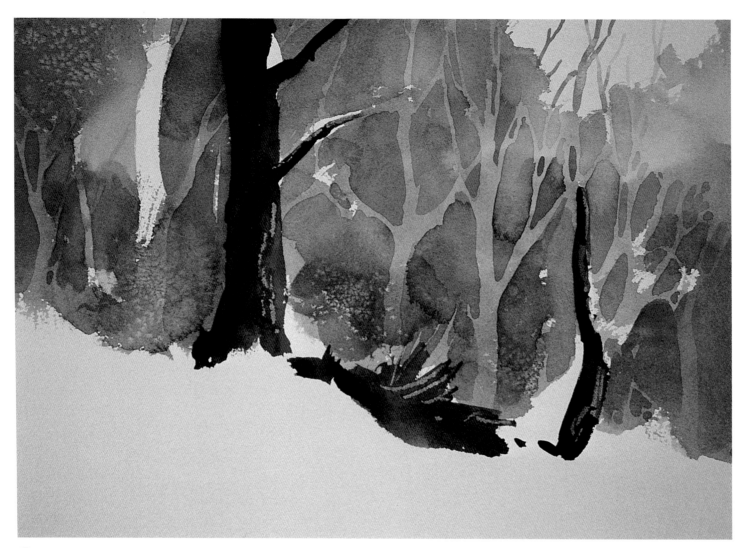

3 PAINT BACKGROUND TREES

Negatively paint in two or three more trees by strengthening the background colors around the tree shapes you create. Be sure you space them unequally apart for a natural look. (Odd shapes also heighten the design qualities.) Add positive branches in the sky area as extensions of the trees.

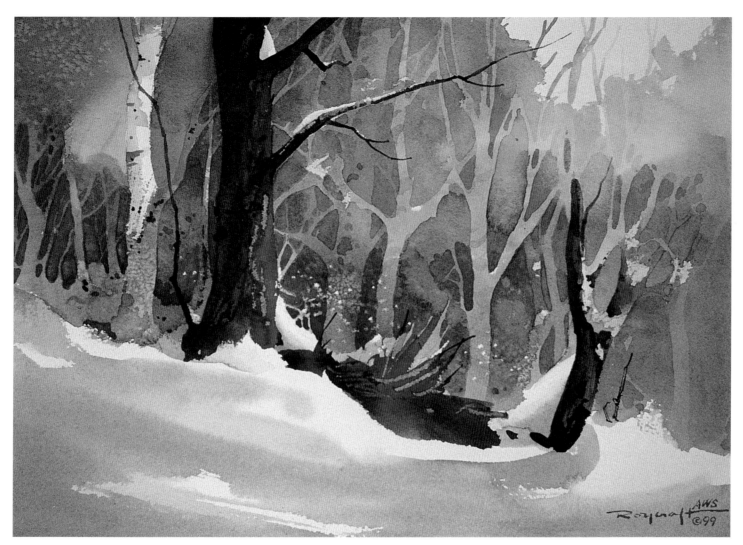

4 FINISH

Add more negative trees and branches, and strengthen the shadows between those already constructed. The background is darkened with each glazing. Add snow shadows with Cobalt Blue and a little French Ultramarine, plus small details to complete the painting.

FAT TUESDAY

10" x 14" (25cm x 36cm)

demonstration
Dune's Edge

Wiping out can be accomplished in many ways. It can be done with a damp brush, knife or tissue when the paint is wet, or dried paint can be scrubbed out with a wet toothbrush and blotted with a tissue. It is used many times as a corrective device. In Chapter 4, you'll use this technique extensively to paint flowers. For *Dune's Edge*, we'll use this technique with the help of a stencil.

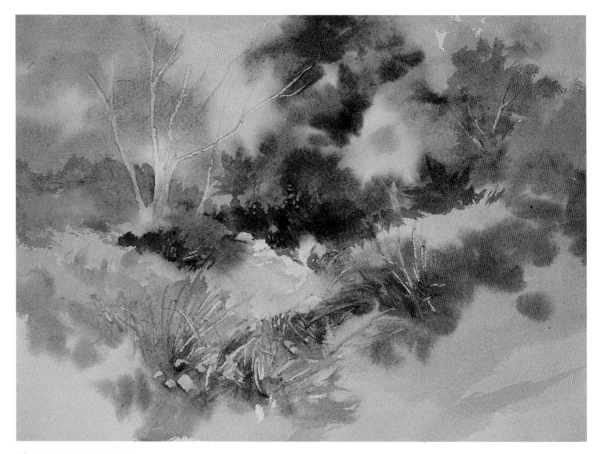

1 BEGIN PAINTING
Dampen your paper on both sides with a sponge. Then apply Raw Sienna, Burnt Sienna, Antwerp Blue and Cobalt Blue wet-in-wet to obtain the value pattern shown. With a knife, scrape out tree trunks, branches and grasses. Staple the paper to a board to finish drying.

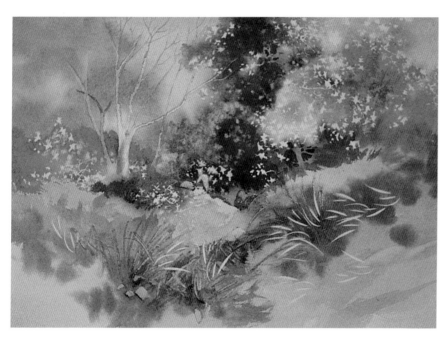

This leaf stencil pattern is similar to the one used for *Dune's Edge*.

2 WIPE OUT WITH STENCILS

Make leaf and grass stencils (see sidebar) to facilitate scrubbing out those areas with a damp toothbrush. Lift the softer areas with your Incredible Nib and a Fritch scrubber.

HOW TO CUT A STENCIL

To cut a stencil, place a piece of tracing paper over your painting and trace the shape you want to wipe out. Then place a piece of glass over the tracing paper to protect it from the heat of your stencil-burning tool. (I put tape around the edges of the glass to prevent cutting myself in handling.)

Next, place a piece of translucent stencil film on the glass and trace the image with the burner. Move quickly to prevent burning a hole. The electric burner is like a tiny soldering iron with a sharp, curved tip. As it melts the stencil to cut it, it leaves beads of plastic along the cut edge. These beads, or burrs, should be removed with a sharp razor blade so the stencil will lie flat.

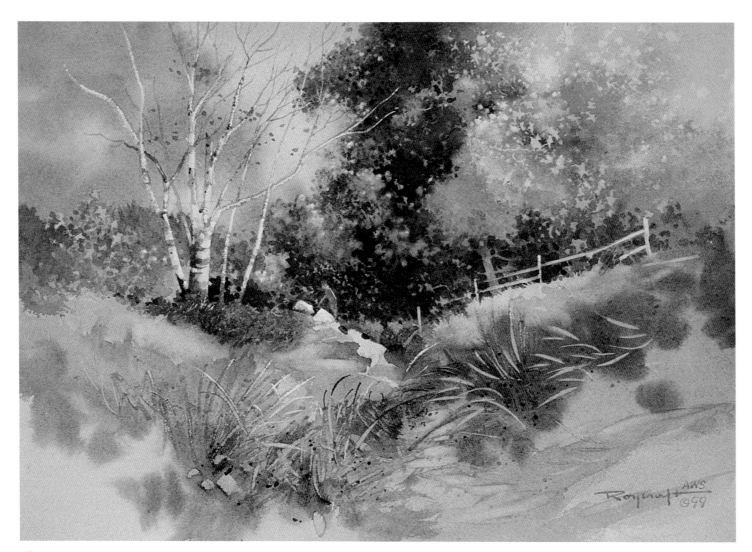

3 FINAL TOUCHES

Strengthen the shadows with Cobalt Blue and French Ultramarine, and brighten the sunshine areas with Winsor Lemon. When the paper is thoroughly dry, use a sharp razor blade to scrape out highlights on the birch trees.

DUNE'S EDGE
10" x 14" (25cm x 36cm)
Collection of Fred Trimble

Build on "Bones"

The stems, branches and tree trunks in landscape painting are the "bones," or structural elements, of the composition. Their structures define the character of the painting. Vertical and horizontal shapes indicate peace and serenity; diagonals introduce action into the picture. The bones are required to give a composition strength and stability, and usually appear in some degree as a fan pattern. Buildings or other manmade objects can also be part of the bones. The diagonals of the snowbank and the fallen tree in *Big Bend* give action to an otherwise peaceful scene.

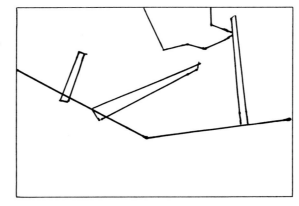

Diagram of the bones, the trees in this painting, as well as two action lines—the primary line at the top, and the secondary line at the bottom.

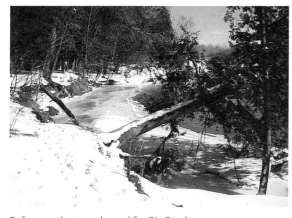

Reference photograph used for *Big Bend*.

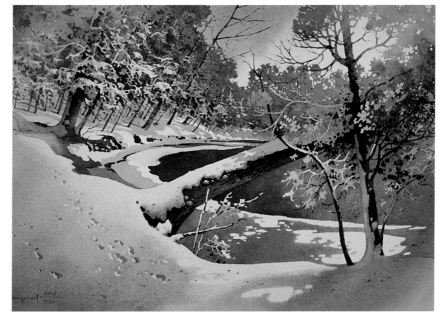

Notice how diagramming the basic structures improves the composition to make the painting more interesting than the photo we started with.

BIG BEND
14" x 21" (36cm x 53cm)
Collection of Nancy Meek

Add the "Flesh"

The leaves, needles, flowers and small details in nature are the "flesh" of a painting. They are abundant in summer and sparse in winter, depending on the type of the tree or plant. The dropping of composition chips can help you in composing the smallest details of your painting.

Remember, you need to have bones in addition to flesh for structure. I liken it to painting a hand: Fingers without bones would look like just a bunch of sausages. Each of these various building blocks can be shifted around to obtain the best composition. *Flushed* illustrates how the bones of tree trunks are necessary in the painting to give strength to the mass of leaf structures.

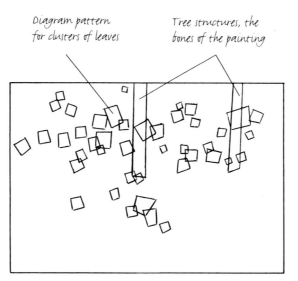

Diagram pattern for clusters of leaves

Tree structures, the bones of the painting

This diagram shows the bones (trees) and leaf structures for *Flushed*. The dropping of composition chips produces an interesting pattern of shapes and sizes and unequal spaces between. Each abstract shape represents a cluster of leaves.

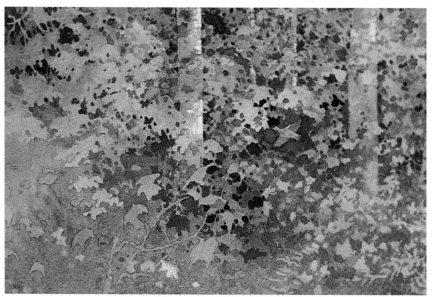

This detail of *Flushed* shows how abstract diagramming becomes reality.

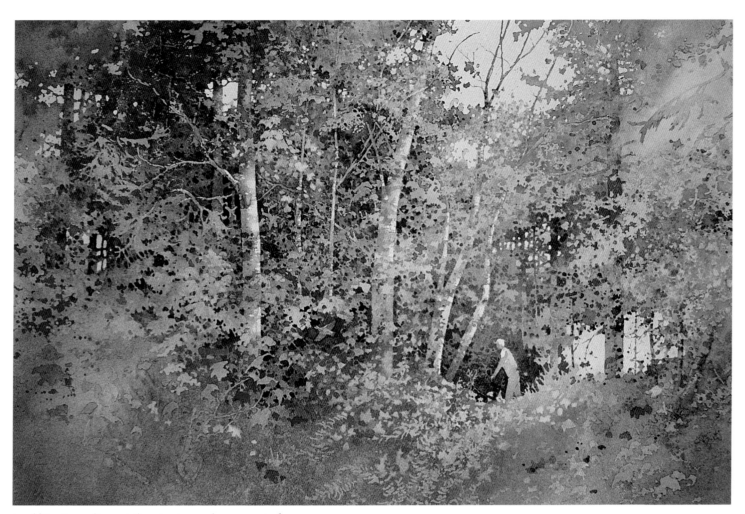

In addition to masking out, there is a tremendous amount of negative painting involved in creating the multiplicity of leaf patterns. Also, some leaf patterns were made by wiping out using a stencil. Each method creates a different illusion, adding to the effect of the finished painting.

FLUSHED
14" x 21" (36cm x 53cm)

Incorporate Symbols

One of the major challenges an artist has to contend with is turning a two-dimensional piece of paper into a live, three-dimensional story that conveys emotion and creates enough impact to move its audience. This is no small task.

Symbols, and even colors, can convey feelings of joy, sorrow, hate, reverence, greed, danger, purity and so on. We see symbols all the time in our everyday lives. Railroad crossing signs have crossed diagonals signifying danger. The spires of gothic cathedrals are arrows pointing toward heaven, and many times the floor plans are in the shape of a cross depicting the Crucifixion.

Artists throughout the ages have relied on various symbols to communicate subliminal messages. If you paint things exactly the way they appear, you will never express a feeling in your art, and you might just as well take a photograph. Art is a personal message that comes from the heart. Use all the tools available to express your feelings as you paint.

On the following pages are examples of how I have incorporated symbols in my paintings.

In this thumbnail re-creation of Camille Pissarro's *Avenue De L'Opera*, circa 1898, the lines of the buildings and vehicles resemble the spokes of a wheel, all leading to the hub where the action is.

Diagonal forms convey action in William James Glackens' *Nude With Apple*, circa 1910, as shown in this thumbnail re-creation.

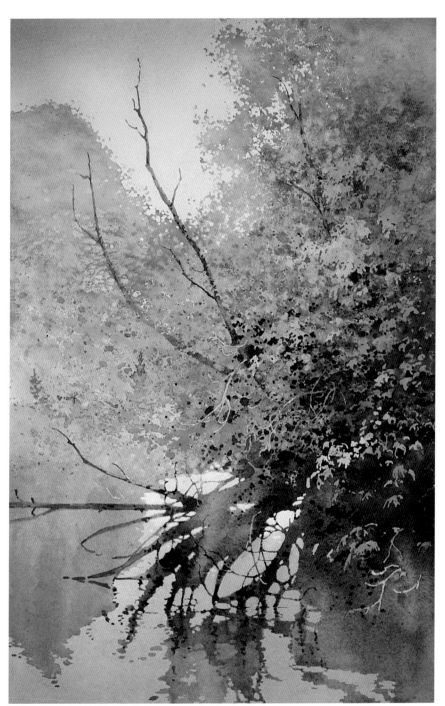

FAN PATTERNS

Fan patterns are one of my most important tools in composing a landscape painting. They symbolize vegetation and growth. From the smallest plant to the largest tree, the stem or trunk branches off into various fan shapes culminating with the leaf or needle. The silhouette of these patterns against the sky can provide delicate lacework to supplement the remainder of your painting. This is a good place to use masking, as it leaves a useful hard edge. Here, the fan pattern of the roots is the focal point.

ROOTS AND REFLECTIONS
21" x 14" (53cm x 36cm)

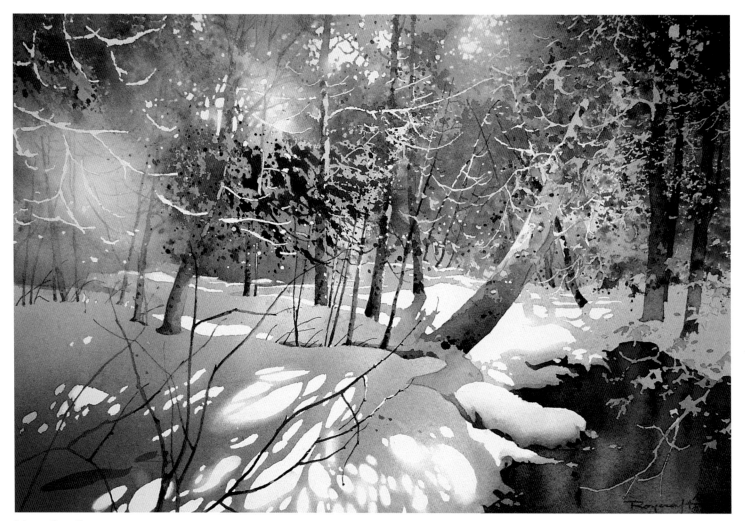

MORE FAN PATTERNS

Here, fan patterns in the form of shadows function as a compositional element, creating a focal point. Interesting shadow patterns can play a major role in the design of your painting.

WINTER FAN SHADOWS

14" x 21" (36cm x 53cm)

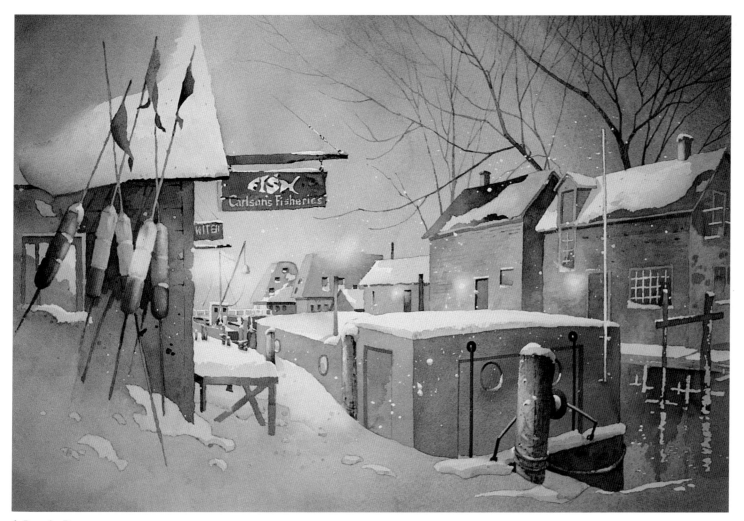

A BULL'S-EYE

The bull's-eye symbol is useful for targeting a specific area of a painting. It automatically establishes a focal point. The setting sun or a lighted bulb can be used as a light source, forming the center of the bull's-eye. Sometimes compositional shapes can be arranged to form a bull's-eye, similar to one-point perspective. *Leland at Rest* was started with a bull's-eye using Winsor Lemon as a light source, then concentric circles of Winsor Red, and finally various blues on the outer edge. The foreground buildings were painted on top of the atmospheric background to complete the painting.

LELAND AT REST
14" x 21" (36cm x 53cm)
Collection of Martha and William Paine

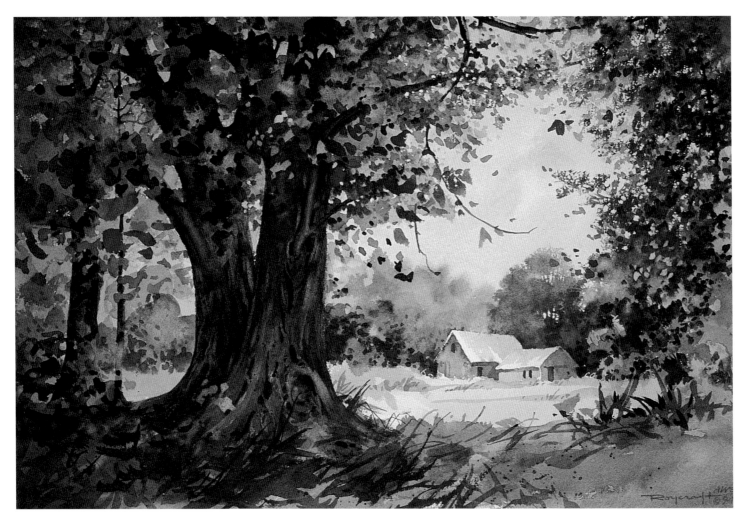

BORDERS AND FRAMES

Borders and frames symbolize containment and can be arranged when composing the bones of a painting. This draws the viewer's eye to the most important elements of your composition. Here, the large trees in the foreground form a heavy border to contain the distant buildings.

A PICNIC PLACE
14" x 21" (36cm x 53cm)

ARROWS

Triangular shapes act as arrows that can lead the eye to the
focal point of a painting. Care should be taken that a composi-
tional triangle does not point out of the painting. In *Maui Mist*,
see how the triangular shape of the foreground rocks leads the
eye into the action of the water.

MAUI MIST
16" x 29" (41cm x 74cm)

DIAGONALS

Diagonals denote action, while horizontals and verticals are more peaceful. In *Winter Tepee* we have crossed diagonals which double the action, creating a box for the center of interest.

WINTER TEPEE
14" x 21" (36cm x 53cm)

Show Silhouettes

The use of silhouette patterns has been one of the most useful tricks I've discovered in painting. In my early days, too much knowledge of a subject got in the way of successfully interpreting a scene. I would observe the immense amount of detail in the world around me, and I wanted to include all of it in my paintings. It was more than I could handle.

Then, it came to me that by half-squinting my eyes, the detail was gone, yet I still knew what things were by their silhouettes. Also, I observed that objects in the distance lost their detail because of haze and light variations.

Now I make an effort to look for interesting silhouettes to identify things by shape instead of by their detail. I save the picky stuff for the focal point, and let the imagination fill in the rest. It has made painting easier for me, and it produces better results. Learn to observe the things that are important, such as shapes, sizes and values.

Try to visualize for yourself where the action line and the secondary action line are in this painting. The large bar between is decorated by the horse stables and leaves of the foreground trees. The background silhouette is only a vehicle for the composition.

THE STABLES
14" x 21" (36cm x 53cm)

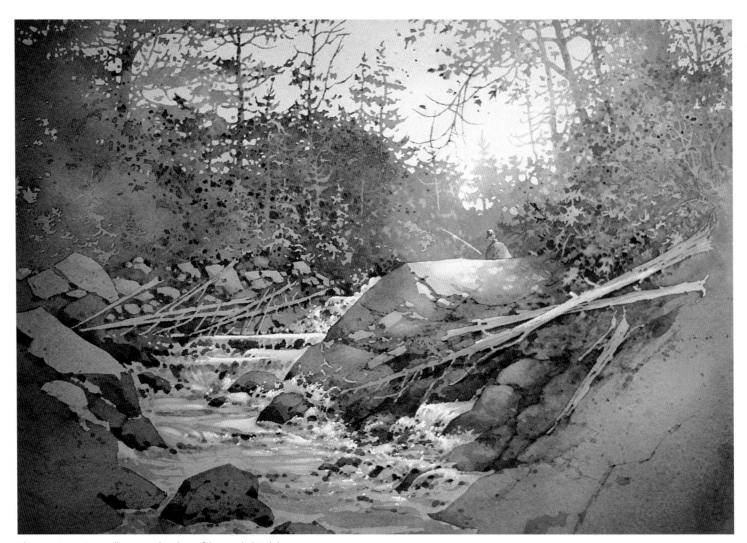

This sunrise painting illustrates the glow of the sun behind the
silhouette of the background trees.

CHIPPEWA RAPIDS
14" x 21" (36cm x 53cm)

The trees and reflections in the water form a double silhouette for a very simple composition.

A QUIET SWIM
14" x 21" (36cm x 53cm)

Keep a Photo File

element 7

I have an extensive file of photographs I have taken through the years that I use for reference while constructing the various elements of my paintings. The unusual occurrences of nature due to weather conditions or natural disasters provide interesting shapes and patterns to build a painting around.

I'm always looking for unique lighting effects, cloud formations, reflective surfaces and specific characteristics of different kinds of vegetation. These are the things that portray reality. Sprinkle this in with the accidents that happen during the free application of paint from pouring and spattering, and you have a personal message to present.

Never try to duplicate a photo; it is only a source of ideas from which to build your paintings through the use of composition chips, diagramming and thumbnail sketches.

These three photos of the Sleeping Bear National Lakeshore were assembled to make the small color thumbnail shown on the opposite page. The shifting dunes change the landscape every year, so now it could very well appear as shown in the final painting, *Sleeping Bear Pathway*.

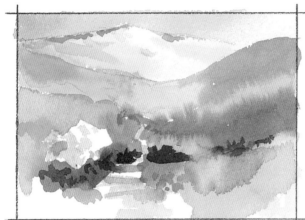

This color thumbnail is the
basis for the final composition.

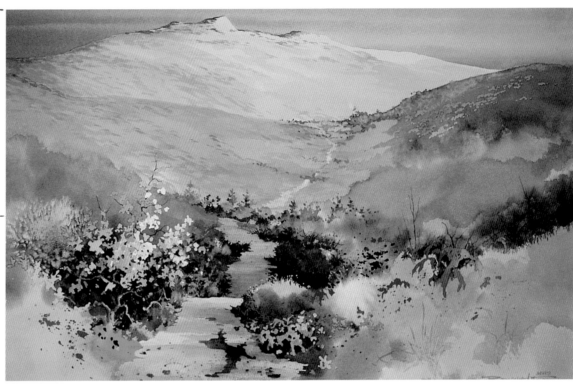

SLEEPING BEAR PATHWAY
14" x 21" (36cm x 53cm)

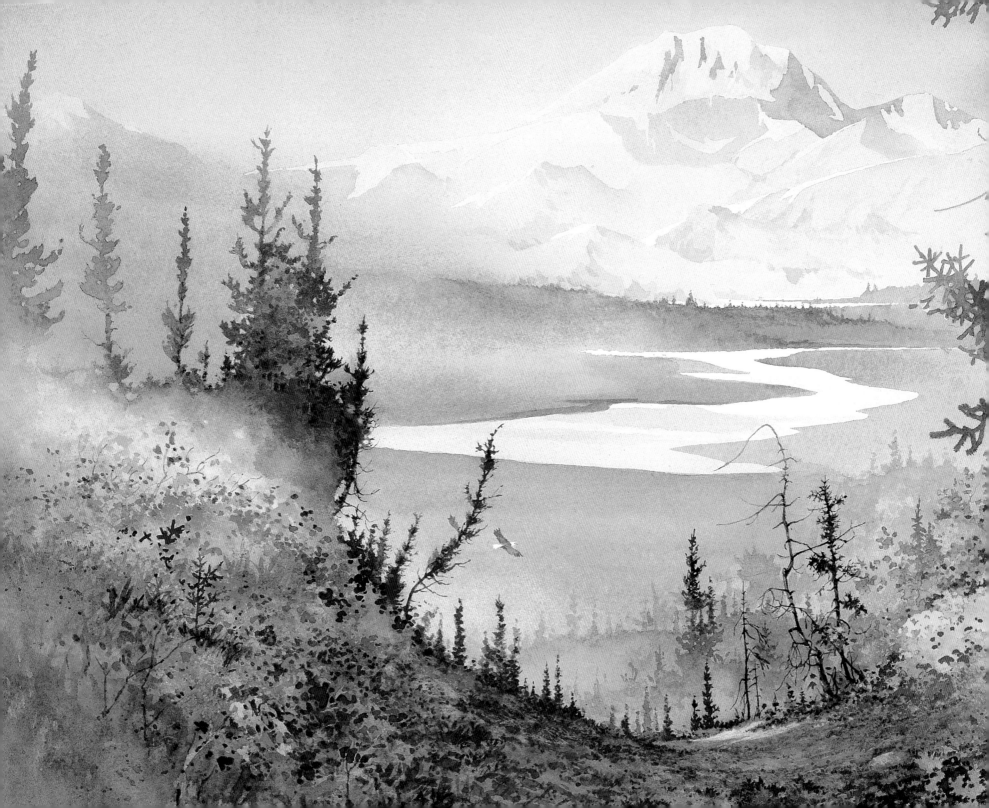

Chapter Three

Let's Make *a* Painting

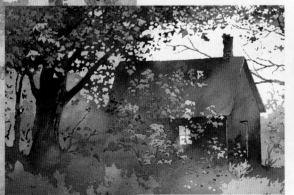

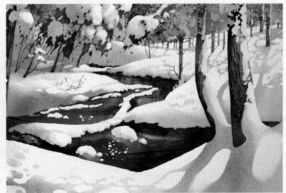

MT. MCKINLEY

21" x 29" (53cm x 74cm)

Collection of Rosalie and John Nicoll

A Four-Step Process

Now that we've explored the building blocks that form the underlying structure of a composition, let's go through the steps necessary to give your work the spontaneous edge it needs. You must remain open to exploration, the free-flow of color and the unpredictable results that happen. That's why I've developed this four-step process that yields illusions of nature beyond my own comprehension. With each new venture, I'm not exactly sure where my masking, pouring and spattering will lead, but I know the unpredictable nature of these steps will create lively foundations for my paintings.

My process involves first pouring cool primary colors on watercolor paper to create atmospheric conditions, including lighting, shadows, reflections, mist, fog and blowing snow. Then I use spattering, or "throwing" of paint, to produce the texture of sand, leaves, evergreen boughs, wildflowers and other vegetation. However, since I also want to control the light source and other details that might be lost in the uncontrolled application of paint, I use masking liquid to preserve these areas. Using these three steps, I'm able to complete more than half of each painting without touching the paper. The last step is brushing on the final details.

FOUR STEPS TO MAKE A PAINTING

1. Plan and preserve the lights with masking.
2. Pour on the atmosphere with the cool primaries.
3. Spatter on the texture. (For some paintings, you might skip this step and go straight for the brushwork.)
4. Finish with brushwork using the warm primaries.

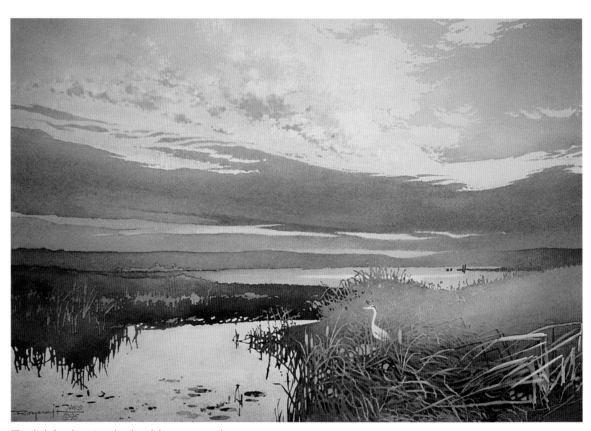

The dark, low-hanging cloud and the grasses in the swamp comprise the middle-value shape in this painting. The light sky area, water and grass detail in the foreground were masked out in preparation for the atmospheric pourings. The dark grassy areas were painted before the masking was removed. The water was poured on last, reflecting the colors in the sky. Shadows in the clouds were painted wet-in-wet. The blue heron was wiped out last using a toothbrush and a specially cut stencil.

RARE MOMENT
14" x 21" (36cm x 53cm)

Winter Stream

This demonstration starts with a reference photo, but ends up looking quite different. It was only because of the thumbnail and diagramming that I was able to make this broad of a transition. Thanks to the four-step process of masking, pouring, spattering and brushwork, the final result is a spontaneous painting with textures, tones and temperatures that convey the illusion of spatial depths. It's the accidentals that are the most beautiful part of the painting.

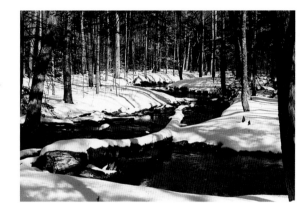

REFERENCE PHOTO
The only part of this photo that rang my bell was the fallen tree leading into the scene. However, this photo lacks a good foreground.

DIAGRAM
I made a couple of thumbnails first and finally came up with this solution by introducing a large tree on the left, balanced by twin smaller trees on the right. This required more foreground snow to tie these elements together.

Diagramming becomes important when the artist strays this far from a reference photo. I established an action line to introduce a piece of the sky (light source). I then added the secondary action line at the base of the wooded area, which breaks up the space into the three areas of the bar theory.

Next I added the bones for the foreground trees from my thumbnail sketch. These trees aren't in my photo, but are necessary to provide a foreground. Small chips are placed to represent the stream, followed by additional chips dropped to represent snow-covered boughs, giving the composition a spontaneous feel.

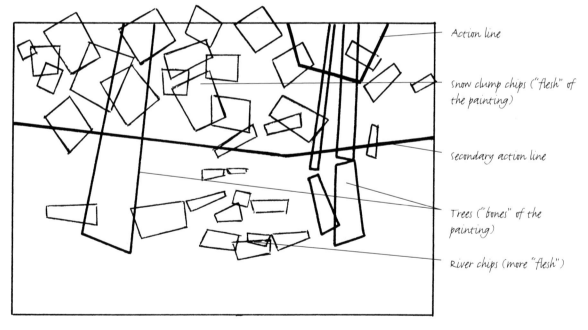

Action line

Snow clump chips ("flesh" of the painting)

Secondary action line

Trees ("bones" of the painting)

River chips (more "flesh")

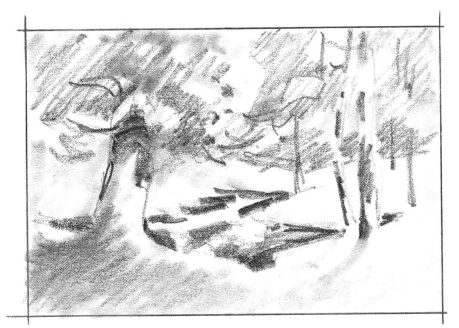

FINAL THUMBNAIL

A final thumbnail sketch is necessary to establish the tonal patterns, remembering that the light source and highlights on the snow are the lightest portions. The middle and dark values are adjusted through several thumbnails to find the best combination. I resorted to my photo file and selected trees to provide the bones of my painting. Another photo furnished the details for the snow-covered branches. I designed the foreground shadows from my imagination, utilizing the light source from the upper right corner as my guide.

 DO MORE THAN ONE THUMBNAIL

Many times I play around with a subject before getting serious. Sometimes you need to create several preliminary thumbnails before the diagramming process to come up with a composition you are satisfied with. When you're ready, make the final thumbnail of value patterns to follow when you begin your painting.

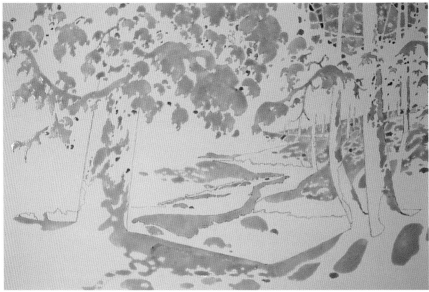

1 PLAN AND PRESERVE THE LIGHTS

Draw the main contour lines of the composition with a sharp 4B pencil on a stretched sheet of 140-lb. (300gsm) cold-pressed paper, establishing the action line and the secondary action line from my diagram. Alter the stream from the photo to follow my thumbnail and then pencil it in. I recommend taping the edges of the paper to the backboard with 1-inch (25mm) masking tape to keep the liquid colors from running off the edge during the pouring process.

Next, apply masking to the areas to be saved. Using my value sketch as a guide, mask off the sky, highlights on the snow, the snow clumps on the boughs and any other small details that need to be saved. Keep in mind the negative/positive aspects as to whether you should mask off an object or the space around it. Here, I negative masked the tops of the small trees on the right, while the highlights on the foreground snow and snow clumps on the trees were positive masked.

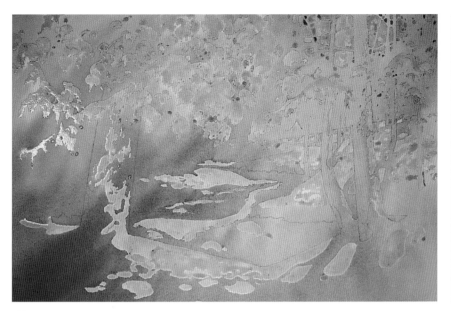

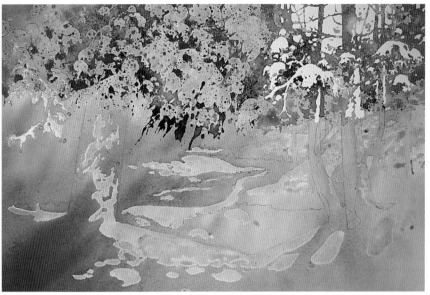

POUR ON THE ATMOSPHERE

When the masking fluid is completely dry, prepare the three cool primary colors for pouring in individual mixing cups or flat saucers. Thoroughly dilute a generous amount of Winsor Lemon, a bright Winsor Red and a cool blue, such as a pure Cobalt with the addition of other blues.

Starting at the light source, spray water on the portion of paper you want the cool yellow to flow over. Run excess water off the paper so the poured paint isn't too diluted. Then pour Winsor Lemon from the light source and guide it with a spray bottle to cover about two-thirds of the paper. Run excess paint off the edge of the paper. Dry the paper thoroughly. (You can use a blow dryer to speed up the drying process between each pouring.) After drying, do two separate pourings of Winsor Red, one on each side of the light source.

The blue represents shadow and should be poured at the corner farthest from the light source. Because it is the most complicated color on the palette, successive pourings of different combinations may be needed to get the color and value you want. The secret is to never pour successive colors from the same place. The overlapping cool primaries result in making every color in the rainbow.

SPATTER ON THE TEXTURE

Once the poured layers are dry, the spattering of the warm primaries adds the texture of the background trees. Using mostly warm primaries and a few cools, mix pure pigments or combinations with enough water to yield a relatively heavy, opaque consistency (see tip on page 66). To spatter, spritz a few drops of water on the paper at the light source. Then load your biggest round, natural bristle brush with a generous amount of paint. Holding the brush at a right angle against a wooden stick (perhaps another brush handle), gently or forcefully tap the brush against the stick over the droplets, causing the paint to spatter across the surface.

Where the paint hits dry paper, hard edges will form, and where the paint hits water droplets, soft edges will result. You can spritz more water over the spattered color to spread and soften it. Look for interesting things to happen, possibly adding a few grains of salt here and there. If the paint gets too dark in some areas, or if the water gets out of control, blot it with a tissue.

I cover the area to be textured with spattering, and vary it with an occasional wet-into-wet wash. Continue until the middle values are completed. Let dry. (After complete drying, I removed some of the masking at the light source to get a handle on how I was doing. I wanted to make sure my values were correct.)

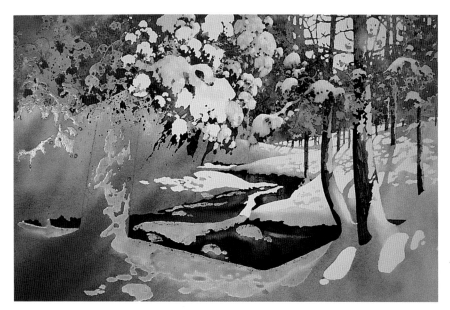

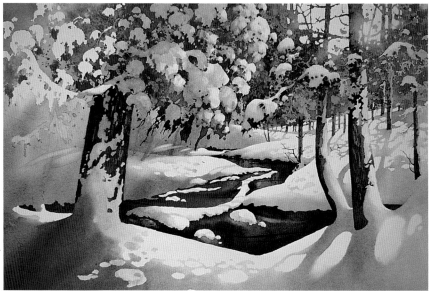

4 START PAINTING TREES AND STREAM

Start painting in the tree trunks with your darkest colors to sense the progress of the three values of your painting. As you proceed, more masking may be lifted to check your progress. Remove masking only where you feel the painting is completed. Continue with the darks in the stream, remembering that water is a reflective surface.

tip **FOLLOW COLORS FORMED BY POURINGS FOR SPATTERING**

Always start at the light source and work outward following the color transitions formed by the first atmospheric pourings. Sometimes tilting the board will help the colors to mix on the paper better. As you move from one small section to the next, change colors according to the underlying cool primaries that resulted from the poured layers. For instance, you might start with a yellow-green in a light area, then deepen the green and bring in blues as you move into a shadowed section. The key to lively color is variety in warms and cools as well as lights, mediums and darks.

5 FINISH WITH BRUSHWORK

At this point, you've completed your larger general shapes with spattering and brushwork on the tree trunks and water. Now it's time to pull everything together with a few last details.

As you remove all the dry masking with a rubber cement pickup, paint over the glaring whites with a small detail brush. Keeping the light source in mind, model the clumps of snow on the tree with the various cool primary colors to give a nice rounded appearance. Some hard edges in the snow shadows on the ground can be softened with a damp Incredible Nib and blotted with a tissue.

Bring some of the paint out over the already painted areas to blend and merge the highlights into the overall painting. When you've finished your last section, check the overall pattern of lights and darks. Some extra pouring, spattering or brushwork may be needed to deepen a few tones and bring attention back to the focal point.

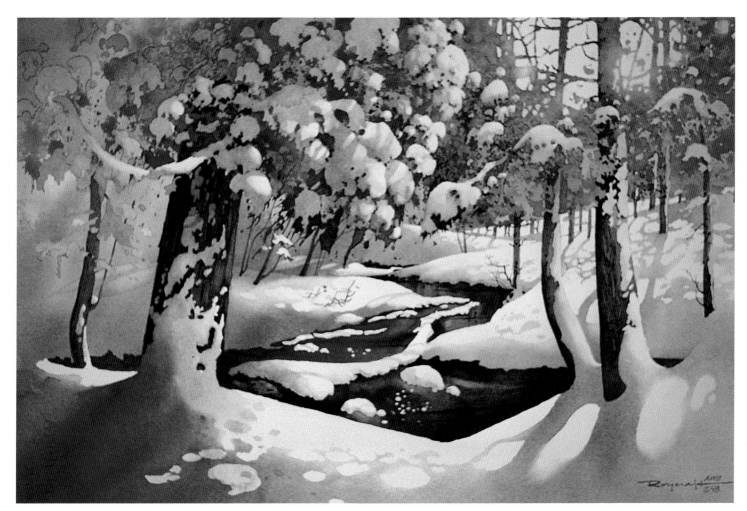

FINISHED PAINTING

As you are finishing the painting, analyze for color, perception, value, balance and the various contrasts that provide depth and harmony. Add small details to provide interest. I completed this painting by adding the small tree on the far left. I felt the large tree by itself was too abrupt and needed that transition for balance. The fallen log in the stream leads the eye into the picture and was the object the painting was built around.

WINTER STREAM

14" x 21" (36cm x 53cm)

Collection of Rosalie and John Nicoll

demonstration
The Hunter's Cabin

November is hunting time in northern Michigan, so don't look for a repairman when your furnace goes out! Little shelters like the one in the reference photo are used only once a year. The hunters are already out in the woods, but the cook has to stay and clean up from breakfast.

In order to get the true feeling of the area, I first recorded it on film and then made a small thumbnail to capture the essence of the atmosphere. When I got back to the studio, I prepared my watercolor paper for the interpretation. Witnessing and absorbing the actual feelings of a scene is the only way an artist can do justice to the final painting.

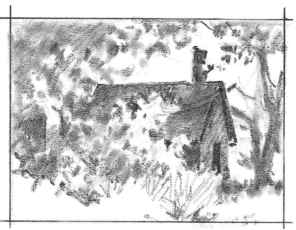

THUMBNAIL
A hunting trip is a very intimate social gathering, so I wanted to add a border around the cabin to portray this feeling. By designing some trees on each side of the building, I form a border that concentrates the eye on the silhouette of the cabin and lends an intimacy that wasn't in the photo.

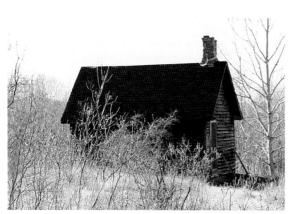

REFERENCE PHOTO
The lacework of the foreground shrubs against the dark building attracted my attention. But, it lacks value unity with the surrounding environment. This is an example in which a thumbnail is necessary to determine the next step.

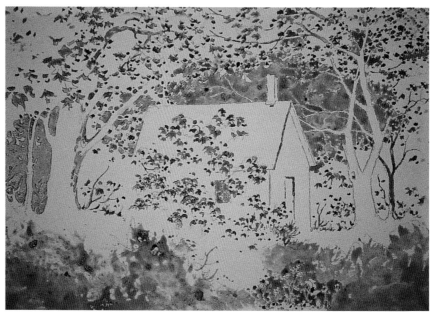

1 MAKE SKETCH AND APPLY MASKING
From the thumbnail, sketch the scene on a half sheet of stretched 140-lb. (300gsm) watercolor paper. Mask out the sky, some light-colored leaf patterns and sunlit foreground shapes. (Mask the foreground shapes by stamping with crumpled plastic wrap dipped in masking solution.) Also mask out the window of the cabin and some of the edges.

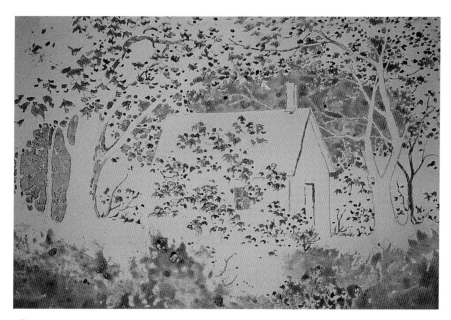

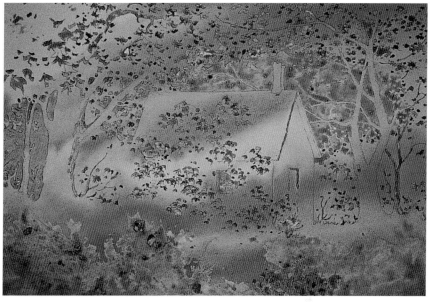

2 POUR YELLOW
Pour cool Winsor Lemon from the light source at the upper-right corner.

3 POUR RED
After the yellow has dried, pour Winsor Red on each side of the Winsor Lemon. Remember to let the paper dry thoroughly between each pouring.

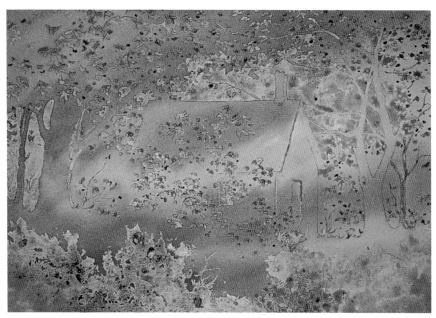

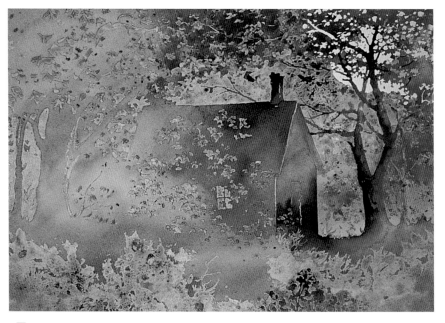

4 POUR BLUES

Pour a combination of blues from the lower-left and upper-left corners to set the stage for the shadow patterns.

5 BEGIN SPATTERING AND BRUSHWORK

Starting at the light source, begin spattering the warm primary colors following the hues formed by the pourings. Use occasional spritzing to help form accidental leaf patterns. Paint the dark corner of the house with a no. 10 round sable brush, fading out in value at the bottom. You may want to lift a small corner of the masking in the light source area to check if you have the right value.

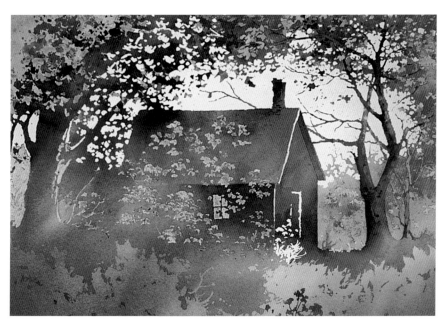

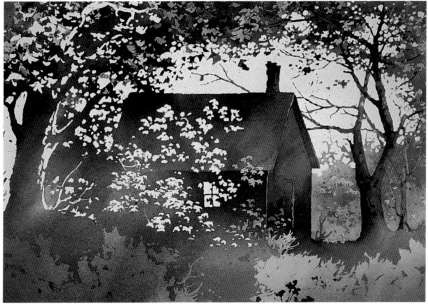

6 CONTINUE ADDING DETAILS AND DO ONE MORE POURING

Continue constructing the tree patterns with spattering, and remove the masking on the foreground area. Then pour a dark mixture of blues from the lower-left corner to give the painting depth.

7 REMOVE ALL MASKING

After the painting has dried, remove all of the masking with a rubber cement pickup.

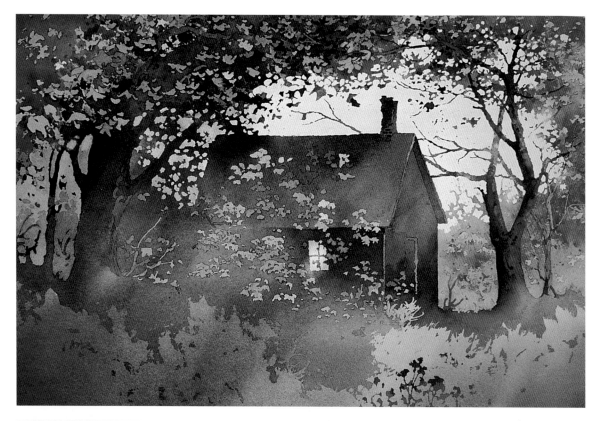

PAINT MASKED FOLIAGE AREAS

Paint the individual leaf clumps where the masking has been removed using various colors, again following the pourings. To make the window glow, use a damp toothbrush or Fritch scrubber to soften the hard edges, then add a little Winsor Lemon and Winsor Red.

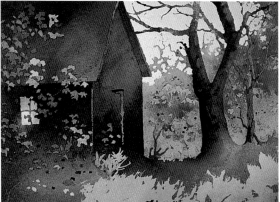

DETAIL
Notice how the tree shadows tie the dark patterns together.

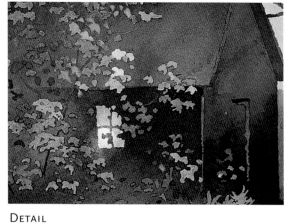

DETAIL
The lighted window indicates life in the early morning as the cook waits for the hunters to return.

9 FINISH

When finishing the painting, I decided to scrub out a portion of the background trees in back of the cabin and repainted it to match the area to the left of the big tree. More tinting of the leaf patterns was done to bring them to the correct color and value. Notice how the leaf pattern detail in the foreground contrasts with the simplicity of the background.

THE HUNTER'S CABIN
14" x 21" (36cm x 53cm)

Canyon Shadows

I've done several paintings of national and state parks. In this photo, the dome on the south rim of the Grand Canyon caught my eye because it provided an excellent focal point, except I felt the composition could be improved on the left side. I decided to bring in a tree to break up the hard line of the rock structure. That's when I decided to rely on the basic principles we've learned about to see how the picture could be improved.

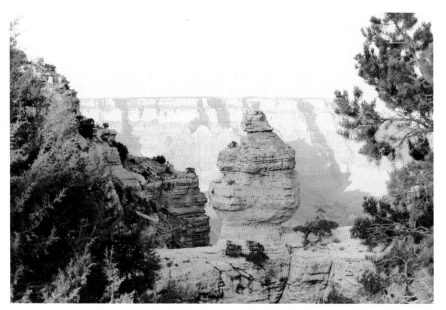

REFERENCE PHOTO
This photo of the south rim of the Grand Canyon was taken at early evening in October.

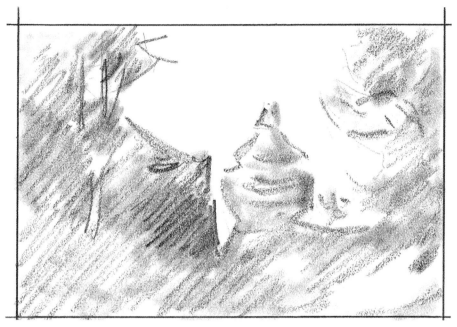

THUMBNAIL
The value thumbnail proves we need to build up the left side with large trees to strengthen that area. The trees were photographed from an area nearby. The light source for this painting is located in the upper-left corner.

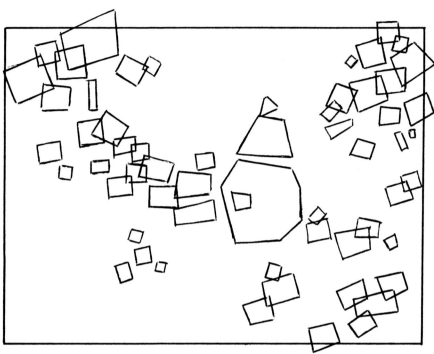

DIAGRAM
Diagramming helps to further establish the composition and the relationship between the rocks and the trees. Notice how the chips represent the balance of elements better than the photograph. Diagramming was a big help in resolving the foreground detail. The small chips in the center at the bottom represent additional small trees brought in to tie the two sides together in a single unit. This completes the border or frame idea that we studied earlier.

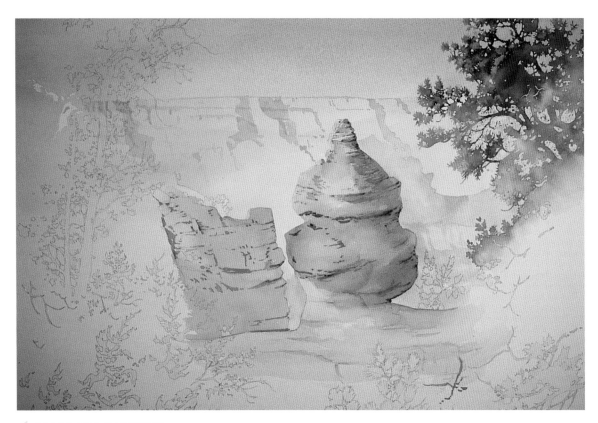

1 BEGIN THE PAINTING

On a full sheet of 300-lb. (640gsm) cold-pressed paper, sketch the image by first penciling in the big divisions of space starting with the action line, which divides the foreground from the background. Then start breaking up each individual area into smaller pieces of detail until the whole sheet has been identified.

Next, paint the shadows of the distant canyon wall with Cobalt Blue and let it dry. Then pour the three cool primaries over the sky and distant canyon walls to make the background.

To paint the tree on the right, first apply masking to the sky holes, leaving the outside edges to be painted in with a splayed round brush to give the appearance of needles (see opposite page). Finish the tree by changing colors and values to give it a three-dimensional appearance. Use Aureolin, Antwerp Blue and French Ultramarine. Then remove the masking in the sky holes and paint them to match the other portions of the sky. This area is now complete.

Begin working on the dome next, making sure to give it a feeling of roundness. Add the first washes of the adjacent rocks using Aureolin, Brown Madder and Cobalt Blue.

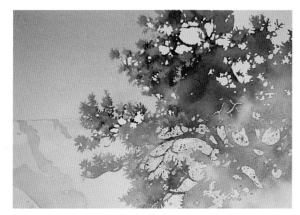

Detail of finished part of tree. At this point, the masking on the sky holes is removed and ready to be painted.

SPLAYING YOUR BRUSH
Pinch the bristles of the brush between your thumb and forefinger to paint needles, grass or other details.

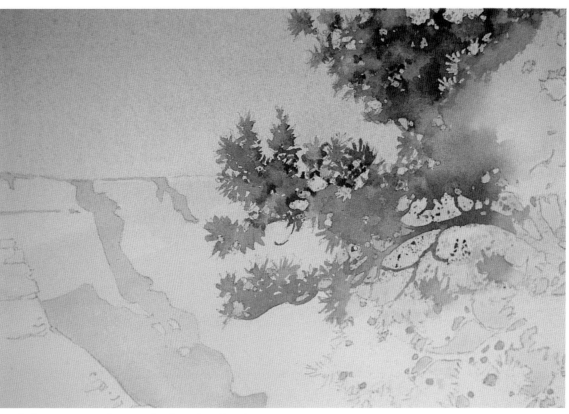

Detail of tree at upper right, painted with a splayed brush.

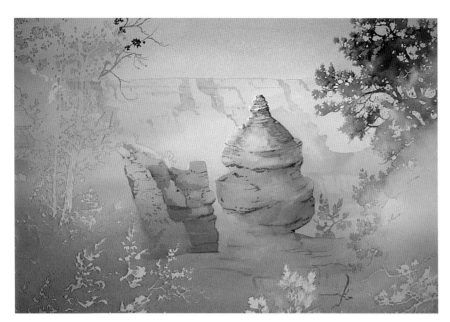

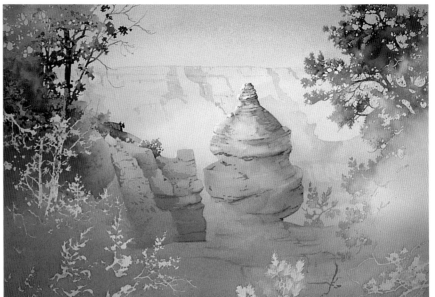

2 POUR FOREGROUND SHADOW

Now mask the foreground foliage and the sky holes of the tree on the left. Then pour on the foreground shadow with shades of different blues. It usually takes more than one pouring of blues to give it the saturation it needs for the full value.

3 PAINT THE TREE ON THE LEFT

Using Aureolin, Antwerp Blue, French Ultramarine and a little Brown Madder, paint the tree in full value and color to make it stand out from the background.

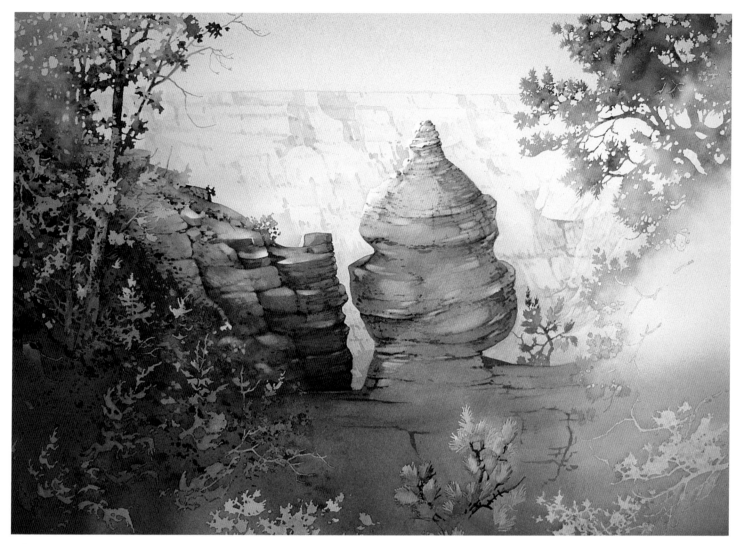

4 **MODEL THE ROCKS AND DOME**
Model the rocks and dome in full value. For the
first time we can now begin to feel the depth of the
subject matter.

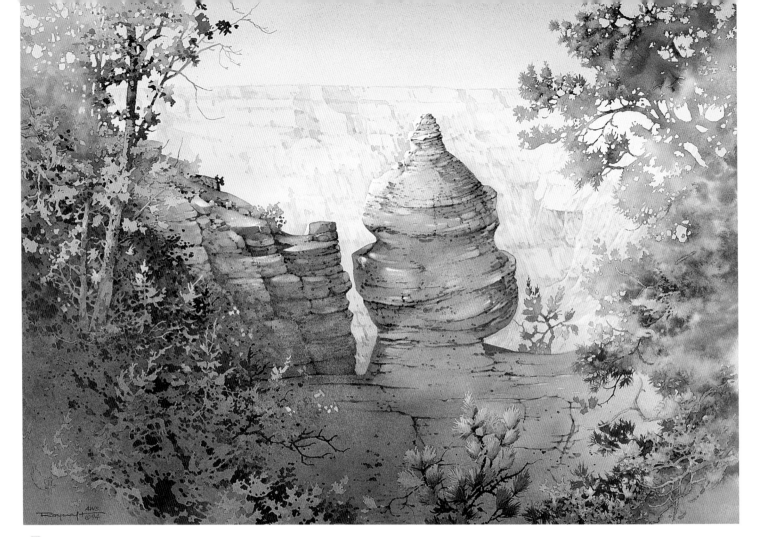

FINISH THE DETAILS

Complete the foreground detail using all colors on your palette as the masking is removed. The trick is to define detail, yet keep it all in shadow. The orange in the dead branch helps to relieve the dullness of the foreground shadows. Sometimes an area needs to be lifted and then repainted to define each part. Keep working until it looks right. Compare this finished painting with the original photo to see if the changes added to the vitality of the scene.

CANYON SHADOWS
21" x 29" (53cm x 74cm)

Simple Keys for Evaluating Your Painting

In one of the first classes I held in my studio, I set up a still life for the students to paint. To my amazement, one person interpreted a tall, slender object to be short and wide. My first reaction was to criticize, and then I thought, no, that is this person's interpretation of the subject. Actually, it looked kind of nice. It showed good design, if not good drawing skills.

I then recalled how Picasso distorted things for the sake of design. So I will list here broad objectives instead of hard-and-fast rules. One of the first things I learned from my students is that rules seem made to be broken. Rather, I would like to stimulate your imagination into new areas of achievement.

As I finish a painting, I have a few simple criteria to evaluate the final product. It doesn't matter whether your work is representational or abstract. These are the things I look for:

◆ **Value.** Check this one first. To me, this is the most important ingredient in a painting. Almost anything can be made to look good if the values are right. By darkening or lightening certain portions of a painting, the emphasis or focal point can be changed. The composition can be made to hold together instead of being fragmented. The light, medium and dark areas should be distinct and of different shapes and sizes. Keep it simple!

◆ **Design.** This is the arrangement of parts, details, form and color so as to produce a complete and artistic unit. The bar theory along with fragmentation can be a useful tool to aid the landscape painter in the breakup of space. The biggest mistake a beginning painter makes is concentrating on individual parts of a composition instead of on their relationships with each other. Shadows are important to tie parts together, and shadows come from a good light source. Do you have a good light source?

◆ **Color.** Color is an emotional tool for the painter. I'm still experimenting with the effects it has on the viewers of my paintings. Colors are like people: Some get along with each other and some don't. I believe in the color wheel regarding which ones are friendly. Complementary colors exaggerate one another's intensity when next to each other, but neutralize or turn gray when on top of each other. Choosing color combinations is more of a personal preference than a "right or wrong" issue.

◆ **Technique.** Technique is a reflection of the individual artist. It says who you are. Imitating another person's technique is a way of learning, but it may not be *you*. Whatever your technique, it should be pleasing to the eye. Does your work reflect what you believe? Does your painting convince the viewers, or leave them wondering why you painted it? Get your message across.

Finally, with regard to watercolor, it shouldn't look too labored no matter how long it took to paint. It should be fresh and exciting, and should look like it just happened. No matter how successful you may feel, you should always try to climb one step higher. If you are entirely satisfied with your work, you are not learning.

Chapter Four

Two Fun Ways
to Paint Flowers

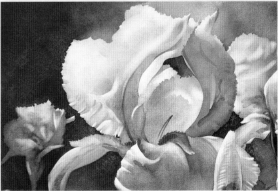

GOD'S PROMISE
21" x 29" (53cm x 74cm)

Interpreting the Different Personalities of Flowers

I guess my love for flowers goes back to my mother, who always had a big flower garden. She said that working with them was a welcome relief after a hard day's work, and it helped her to relax. I've always painted flowers but never felt I could compete with the technical people who painted every petal just perfectly. I would visit the botanical gardens and see people sitting on the floor studying and sketching every single detail. That wasn't my cup of tea.

As I developed my atmospheric approach to painting, I felt the need to include flowers along with my landscapes. They present different shapes, sizes and colors to work with. I experimented with the action line and diagramming and found it worked fine here, too. My yard is hilly and much of it is in shade, so I'm limited in the space I have to grow flowers. The ones presented in this chapter have all been grown in my limited environment.

The iris is one of my favorite flowers to paint because of its large and interesting profile or silhouette. It adapts readily to two fun ways to paint flowers: by masking or wiping out—sometimes both. First, we'll employ the traditional theories I use for painting landscapes, and then we'll use the wiping-out technique, which adapts itself to flowers particularly well because of their large profiles.

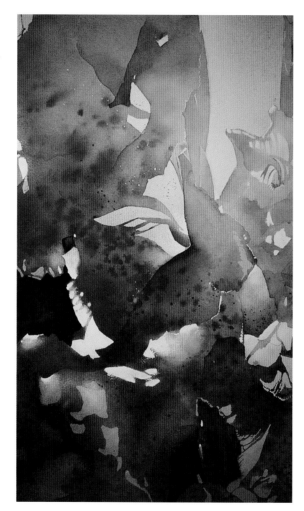

This late-blooming gladiola impressed me with its size and vitality. I wasn't as concerned with its botanical representation as I was with its strong abstract pattern. I put the cut flower in a glass of water and placed a light behind it to bring out this dynamic quality. After penciling it on a half-sheet of stretched 140-lb. (300gsm) watercolor paper, the background and highlights on the flower were masked out so the gladiola could be painted wet-in-wet. Smaller details were added when the paper was dry. Finally, the masking was removed and the background was painted instead of poured to control the wash.

I'M GLAD
21" x 14" (53cm x 36cm)
Collection of Stella Sharp

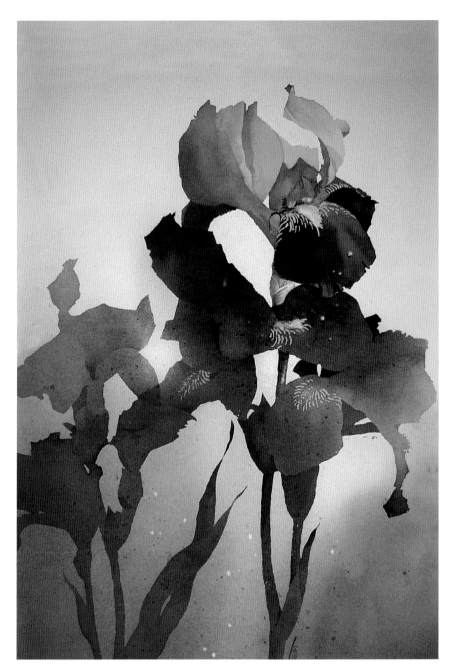

Purple Iris represents a simple method of interpreting the majestic feeling of this grand lady of the garden. By masking around the entire flower and shadow, I retained the perfect silhouette during the many wet-in-wet washes necessary to delineate the many facets of the iris. When every detail was finished, the masking was removed, allowing the atmospheric background to be poured in with the cool primaries. The flower and shadow should be thoroughly dry before the pouring is started to prevent runoff as the paint goes over the lower portion of the flowers.

Purple Iris
21" x 14" (53cm x 36cm)
Private collection

Iris Group

Masking forms an allover design pattern as it protects your paper from subsequent applications of paint. Using the same rationale as in my landscapes, in this demonstration the cool atmospheric primaries are poured onto wet paper from different locations to form the basis for the final construction of the flowers themselves. Be sure to provide a definite light source to form the shadows.

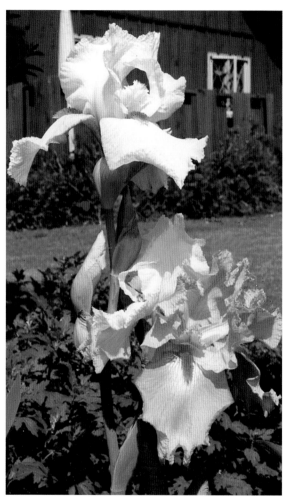
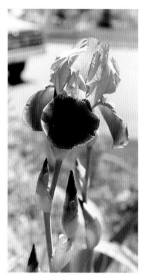
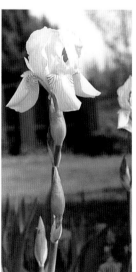

Reference photos

DETERMINE THE ACTION LINE

Begin your preliminary planning by finding an action line. The action line for *Iris Group* forms an interesting initial breakup of space.

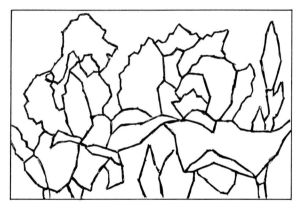

DIAGRAM YOUR PAINTING

As the additional fragments of the iris are added to the action line, we complete the entire division of space into various sizes and shapes. Even at this early stage of planning, the overall appearance should be pleasing to the eye.

MAKE A THUMBNAIL

A thumbnail will help you determine value patterns for your painting.

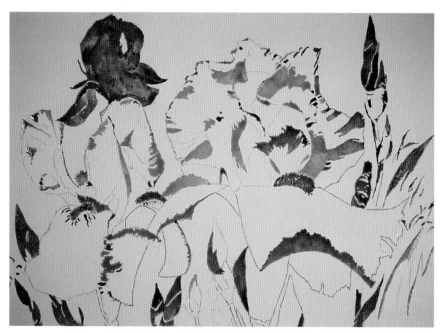

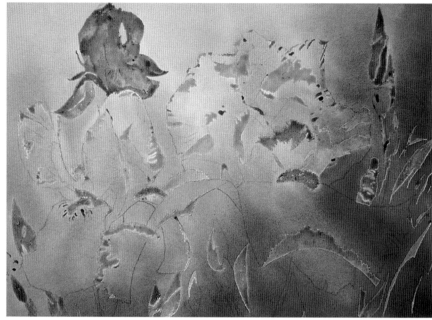

1 MASKING

After establishing an action line and diagramming, carefully pencil your subject on a stretched half-sheet of Arches 140-lb. (300gsm) cold-press paper with a 6B pencil. (I find it necessary to pencil in whenever I have masking involved.) Apply masking to the iris in the left background and the highlights on the other blossoms to preserve their delicate nature during the pouring process.

2 POURING

Successive pourings of the cool atmospheric primaries of Winsor Lemon, Winsor Red and various blues lay the foundation for the finished painting.

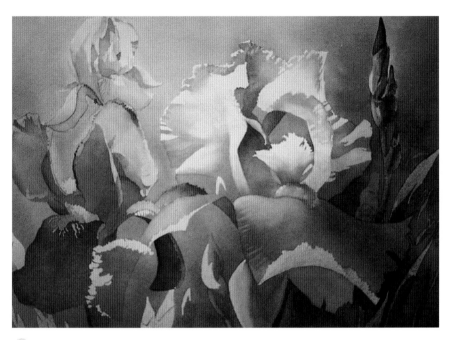

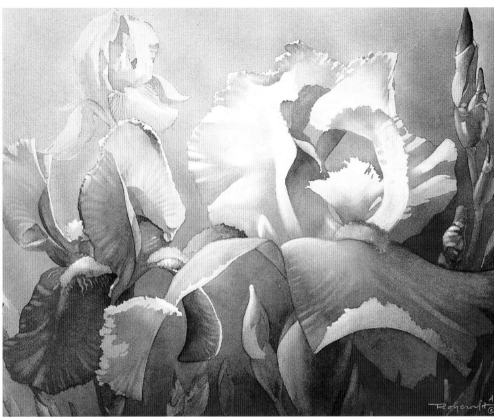

DIRECT PAINTING

When the paper is dry, remove the masking from the iris next to the light source and begin your direct painting, wet-in-wet, using a no. 7 round sable brush. I used both a warm and cool yellow plus a little Cadmium Scarlet to model it. Then remove the rest of the masking and start softening some of the hard edges with a moistened Fritch scrubber as you begin modeling the petals.

The large iris, being white, will have a combination of warm and cool shadows to give it roundness. Apply colors wet-in-wet, following the influence of the background pourings.

ADDING DETAILS

Following the reference photos, proceed to fine-tune the smaller details, fold by fold, using smaller round sable brushes (nos. 2 and 4). Detailing usually is a combination of lifting and painting. It has to look natural even if it doesn't exactly follow your reference photos. Every detail should look three-dimensional.

IRIS GROUP
14" x 21" (36cm x 53cm)
Collection of Jean M. Grossman

Iris

In this example, diagramming and thumbnails are essential to record the image in your mind, as the flowers are wiped out from the background color while the paper is still damp. There is no penciling or masking, and stretching of the paper takes place during the wiping-out process. (You'll want to staple the paper to the background board before it dries too much.) From my experience, beginning painters adapt to this technique more readily than traditional mechanical methods because they are not bound by exactness in drawing. Each bloom varies in size and shape, so good drawing is not of prime importance.

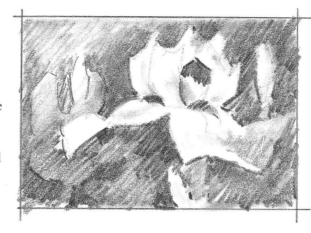

A value thumbnail sketch is particularly important for the wiping-out process since it is the only guide we have for the removal of paint after the background color has been painted.

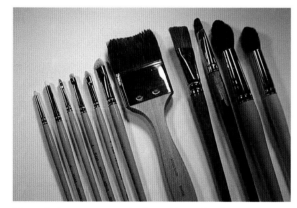

Normally, I'm not too much of a stickler on brushes, as I can paint with almost anything, but the wiping-out process on flowers is an exception. The large flat and round brushes shown here are all natural hair and will pick up moisture and paint to be removed from the big areas. The little Fritch scrubbers are used for smaller details.

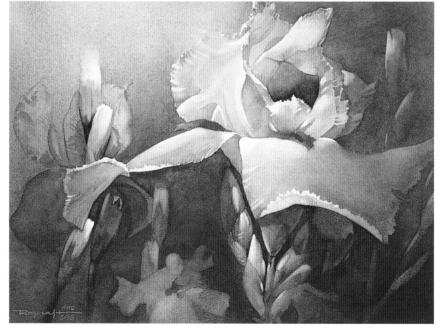

Compare this painting, which used the wiping-out process, with *Iris Group,* which used the masking process, to see how each process resulted in a different mood. *Iris Group* has a sunny look because of the overlapping of the poured cool primary colors, plus the small yellow iris near the light source brightens the painting. *Iris* has more of a moonlit look because the wet-in-wet application of the background formed a cooler area from which the iris was lifted. There is only one white iris, making a simpler breakup of space. We are striving for feelings, not technical perfection.

IRIS
14" x 21" (36cm x 53cm)
Collection of Patricia A. Delonnay

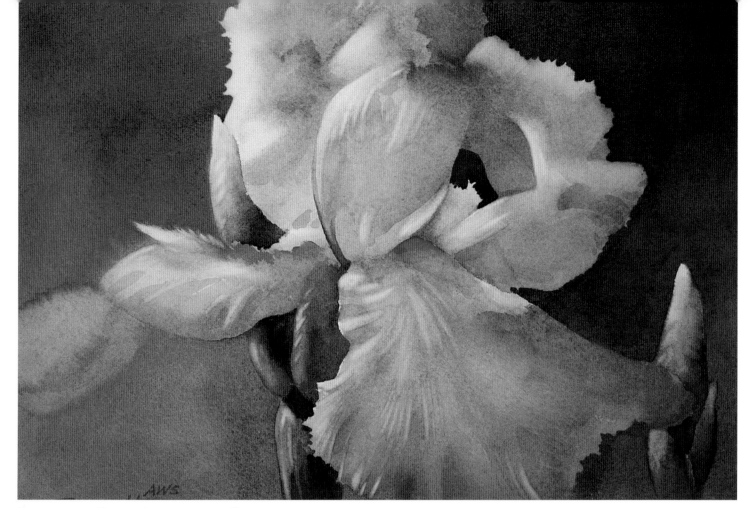

BACKGROUND COLORS INFLUENCE THE COLORING OF YOUR SUBJECT

Here's another example of a flower created with the wiping-out process. Remember that whatever color warmth you decide to make the background, it should be varied in hue, mostly dark in value, and it will influence the coloring of your subject. Moisture content is critical, both in applying the background color and in the wiping-out process. In a sense, it's like sculpting: you are removing material to form your subject. The result is more real and sensuous than with traditional methods that are done in a more mechanical way. Have fun!

IRIS 4 YOU
10" x 14" (25cm x 36cm)
Collection of Delores Jones

demonstration

Peony Power

As you get familiar with these two ways to paint flowers, you'll see that both processes can work together. This combination works well with flowers that have multipetal characteristics, such as peonies, roses and small buds.

To be a good artist, one must learn every trick possible to solve the many problems different subjects can present. Because masking is used here, the watercolor paper must be stretched ahead of time. While it is drying, a thumbnail value sketch is made to work out the composition, as the subject is painted from several photos. Nature doesn't always supply everything just the way you like it, so you may need to make several adjustments before you are satisfied with your thumbnail.

1 APPLY MASKING
After stretching a half-sheet of 140-lb. (300gsm) cold-press paper, make a contour drawing on it following my thumbnail sketch to establish the location of the masking. Then apply masking to the highlights on the peony petals.

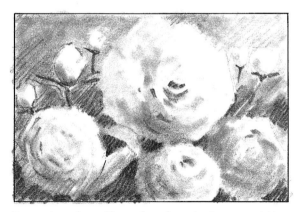

From various photos I have taken of peonies, I composed this thumbnail for *Peony Power*.

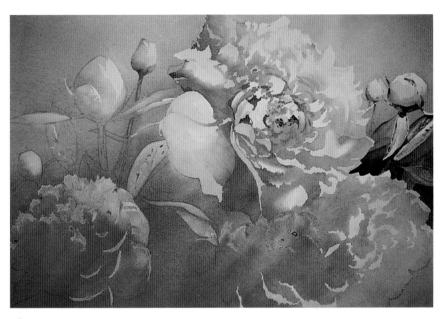

POUR YOUR COLORS

Successive pourings of the three cool primaries set the mood for the finished painting. Notice the light source is at the upper right of the painting.

REMOVE MASKING AND BEGIN DETAILING

Start removing the masking at the light source, and begin detailing the various parts of the flowers and buds. This is done by softening some hard edges with a Fritch scrubber, and deepening shadow areas by painting with a small sable brush. Pink can be produced only by using the cool Winsor Red. A little Winsor Lemon can be added to the sunlit areas, and a little Cobalt Blue to the shadow areas of the various petals. Work petal by petal to give each individual section a three-dimensional look. Darken some of the background on the right to make the large peony stand out.

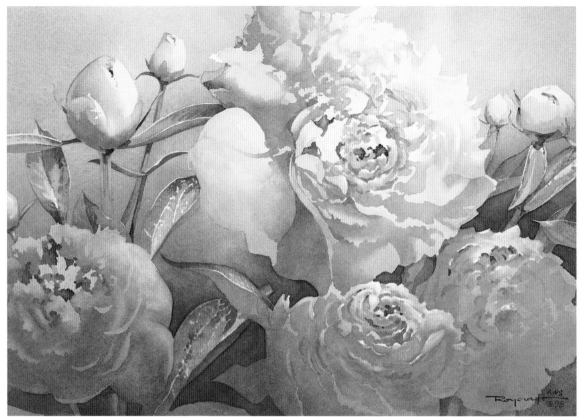

FINISH DETAIL WORK

Strengthen your colors as necessary. Wipe out with stencils to provide more detail in the highlights on the petals. To sharpen an edge with a stencil, use a moistened stiff toothbrush to scrub down to clean paper, then blot with a tissue. The stencil has to lie flat on the paper while brushing to obtain a sharp edge. You must work quickly to keep moisture that might seep underneath the stencil from loosening other areas of the painting.

Next, the shadows and details on the buds have to be strengthened to make them pop. I wanted the peonies in the shadow areas to be quiet. Each of the two yellows in combination with the various blues create a different kind of green. Add an additional pouring of blues to the lower-left corner to put it further into shadow.

PEONY POWER

14" x 21" (36cm x 53cm)

This is a typical flower stencil. Save the piece you cut off so it may be used where you have the reverse shape. Over the years I have collected stencils for almost every occasion. I don't cut individual stencils for every petal or single detail, but instead use part of a master one and mask off the area I don't want to use.

tip **BE CAUTIOUS WITH GREEN TUBE PIGMENTS**

Occasionally, as in *Peony Power*, I use a little Sap Green mixed with other colors to get a truer green in a small area. All green tube pigments are stainers that can't be lifted, however, so be careful when using them. I don't keep stainers on my palette, but instead use them straight from the tube.

Pop Eye

When a subject contains very strong colors, you may need several applications of paint to get the effect you want. For the California poppies in *Pop Eye*, many applications of warm and cool reds were necessary to get the intensity needed to make the flower pop. Remember, the paper is like a blotter. It doesn't have a hard surface like illustration board, so the paint keeps soaking in. The hard part is keeping the painting looking fresh. This requires refloating the previous coat of paint each time a new one is added so it will settle as one application.

This composition was finalized by making several thumbnail sketches to determine how many poppies should be included and the location of the various elements. I wanted to make an impact, so I decided on one large flower plus some buds.

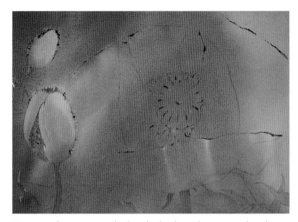

First, masking was applied to the buds and stems and to the highlights on the flower. Again, the three cool primary colors set the stage for the development of the painting. The buds were tinted green by painting Winsor Lemon over the poured blue. The stems are still masked.

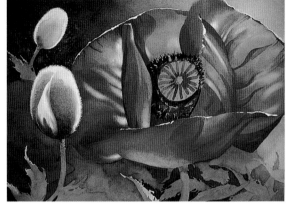

After removing the masking, I began modeling by painting shadow portions of the flower and buds, and lifting or wiping out the highlights with a Fritch scrubber. The lifting and painting sequence continued until I had a three-dimensional effect. The background on the left side was darkened to make the buds and leaves pop.

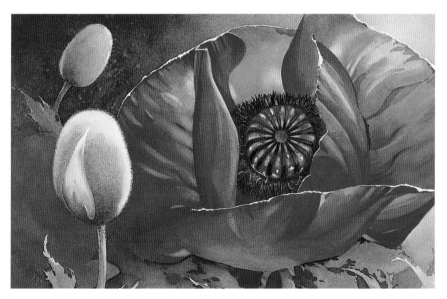

The reds were deepened and small details were accented to finish up the painting. The paper continued to soak up color and lighten as it dried, requiring this additional color to make it pop.

POP EYE
14" x 21" (36cm x 53cm)
Collection of Caleb Luibrand

Grand Opening

For this demonstration, I have to emphasize the importance of the thumbnail sketch, as it is a rehearsal for the big event—wiping out. Here we'll use no preliminary drawing or masking. This time we'll include two big iris blooms to fill a full sheet of 300-lb. (640gsm) cold-press paper. The heavier paper will stay moist for a longer period of time in the wiping-out phase of this big presentation. This is a good loosening-up exercise, and it teaches you to see areas instead of lines. It is not a paint-by-number exercise.

A good action line is a prerequisite to a good composition.

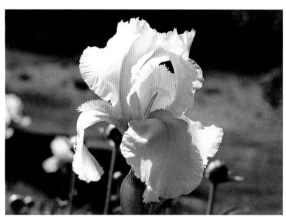

Reference photo

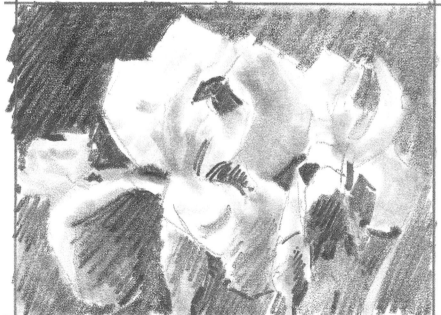

This thumbnail is a rehearsal for the wiping-out process.

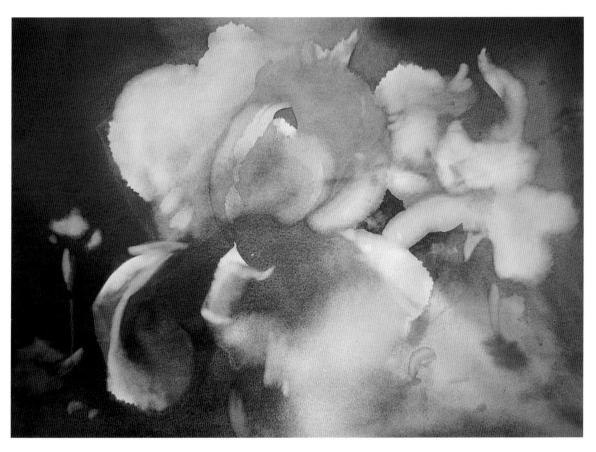

1 LAY IN THE BACKGROUND AND BEGIN WIPING OUT

Prepare your paper by thoroughly soaking it in water, possibly for half an hour, and let it set until the shine disappears. Determine ahead whether you want the background to be predominately warm or cool. (Here, I chose cool.) Then, with a 2-inch (51mm) flat brush, stroke in strong, juicy colors in the background. Tilt your board so the colors run together freely. Beautiful colors result when they do it their way (though you may have to spray a little water in places to help them mix). Keep adding color as it lightens from soaking into the paper. When the value is proper, let it set again until the shine is gone.

Next, staple the paper to your board and wait until the shine disappears. Then begin wiping out the large areas according to the thumbnail with your largest natural-hair brush. Use clean water to rinse your brush and a paper towel to mop it dry as you wipe out. Occasionally you may try blotting an area that is too wet with a tissue. As the paper continues to dry, sharper edges and smaller details can be obtained with smaller natural-hair brushes. Continue wiping until all the major light areas have been removed, as long as positive results are happening. Remember, design is more important than accuracy. Let it dry at least overnight before going to the next step.

2 ADD WARMTH AND BEGIN USING STENCILS

When you get to painting the next day, stop and analyze what has happened and where warmth can be added to give the painting some life, using Winsor Lemon and a touch of Winsor Red. Some of the soft edges may be just right. The edges that need to be sharpened may require a stencil to be cut so you can wipe out further. Here, the background has been masked off with a stencil so the edge of a petal can be sharpened by wiping out with a toothbrush. Blot with a tissue as needed. Modeling is achieved by applying a blended wash from hard edge to soft.

3 CONTINUE MODELING

Each fold on an iris petal has a hard and soft edge, requiring several stencils to be cut to fit the required contour. Scrubbing and repainting section by section is necessary to mold the flower into a three-dimensional piece of art.

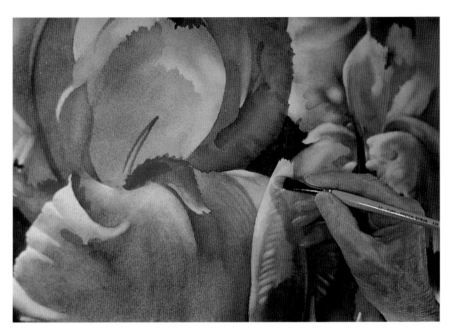

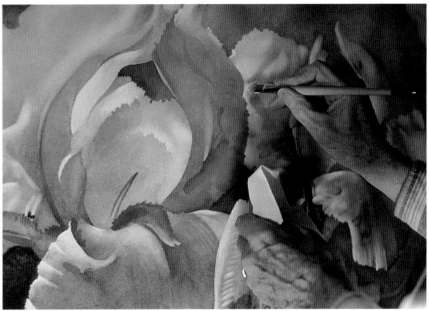

4 CONTINUE WITH SMALLER DETAILS

The Fritch scrubber is an indispensable tool for lifting small areas. It has a shape similar to a filbert brush, but when wet, the specially designed bristles wipe out paint in a very efficient manner. From now on, patience and time are all you need to define each individual area. Here, a highlight on a bud is lifted with a scrubber. Blot with a tissue.

Direct painting with small brushes adds the reflective lights and shadows to define all the details. Use Winsor Lemon in the sunlit areas and Winsor Red mixed with Cerulean Blue for the shadows.

5 DEFINE THE SHADOWS

Darken the shadows with a combination of Winsor Red and Cerulean Blue to allow soft and hard edges to define the direction of light.

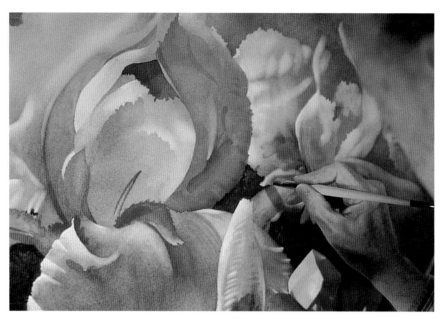

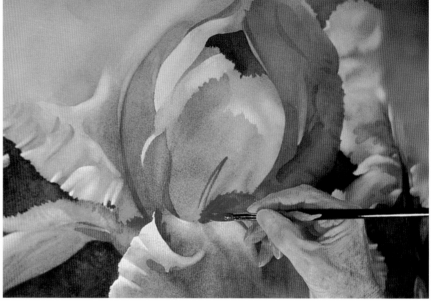

6 ADJUST SMALL DETAILS
Every small detail has to be brought into proper value and color. Use Aureolin to add warmth to background highlights and the foreground bud.

7 ADD FINAL TOUCHES
Add some touches of Cadmium Scarlet to provide the last bit of sparkle.

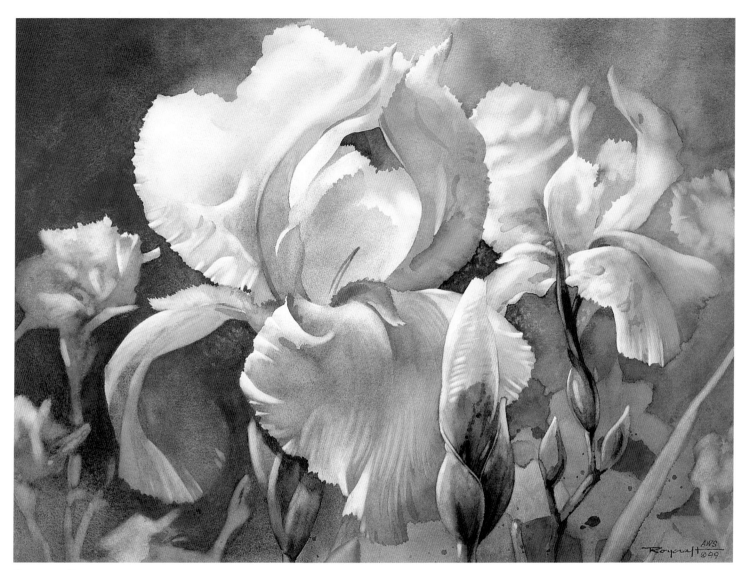

FINISHED PAINTING

This painting was worked on over a period of six months.

GRAND OPENING

21" x 29" (53cm x 74cm)

Collection of Karl and Eileen Rauschert

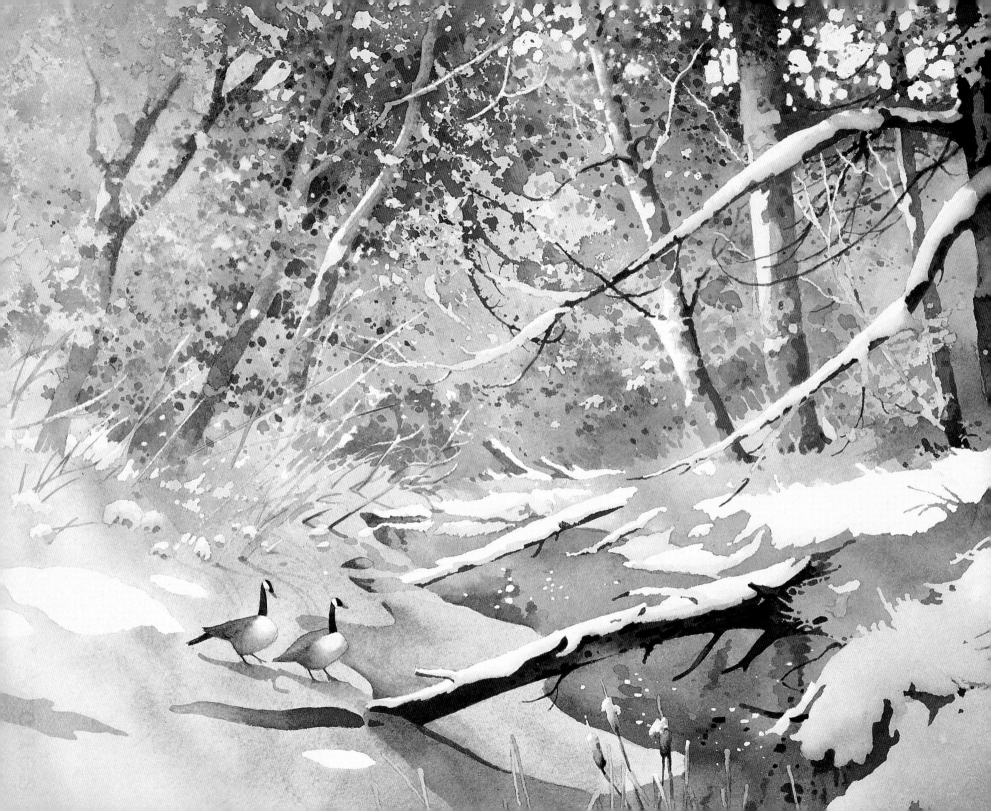

Chapter Five

Having Fun Learning
in the Classroom

WINTER SOLITUDE
14" x 21" (36cm x 53cm)

Common Beginner Questions and Answers

My classrooms are always abuzz with activity, ranging from utter silence to hilarious laughter. There are moments of deep concentration and awe when a saucer of color is poured over a penciled image to obtain an unpredictable atmospheric effect. And then moments later, as the students try these fun ways of applying paint, various responses result when the paint takes on a life of its own. There is never a dull moment. Chitchat starts. Questions are asked. Activity begins. People learn. That's what it's all about!

This chapter records the painting procedure for *Winter Tracks* from the students' point of view. We'll also cover questions and answers presented during a typical workshop. My reward comes when smiles of satisfaction appear at the end of the week. Everyone, including the instructor, learns from each other as we venture into uncharted waters. I will always remember one student's comment: "You won't find new oceans unless you lose sight of the shore."

I explain the procedure of pouring to my class before the demonstration begins.

The masking for *Winter Tracks* is completed.

All classroom photos by Terry Trumble

Q WHY ARE YOU USING YOUR HAND TO SMEAR PAINT?

A The masking acts like a dam when pouring. In order to get some of the Winsor Lemon across to the other side of the paper, I use whatever is handy. I also could have used a spray bottle to push the paint across.

Q WHY ARE YOU BLOTTING?

A Water control is one of the most important aspects of water-color. Excess drops of paint or water are blotted with a tis-sue to avoid backruns or to lighten a value. I prefer to use tissues instead of paper towels because tissues are more sensitive when picking up small areas of water.

Q WHY IS THE BLUE POURED FROM THE PALETTE?

A Blue is the most complicated color in the spectrum, and requires a little of each blue on the palette to get the required hue. Blue is the only primary that has as many different color distinctions, including the four I have on my palette. Purity of a single color is not as important here as with Winsor Lemon and Winsor Red.

Q WHY DO YOU SPRAY THE PAPER BEFORE EACH POURING?

A Paint will not run smoothly with soft edges unless you spray the area with water first. Excess water is always run off the side of the board after each spray to prevent excessive dilution of color. The paper needs to be dried between pourings of different primaries to get nice, clean secondary colors.

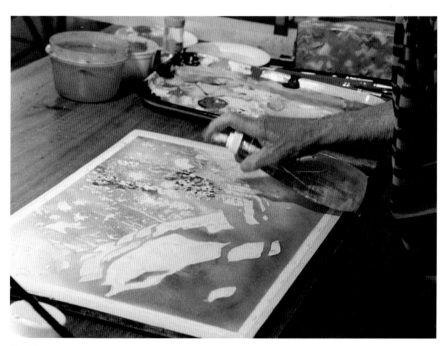

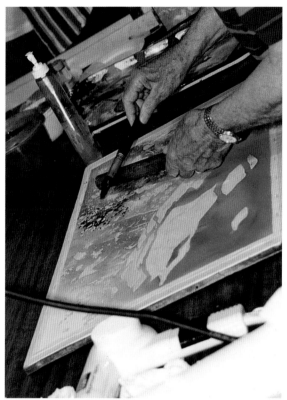

Q HOW DO YOU KNOW WHICH COLOR
TO SPATTER FOR TEXTURE?

A The colors formed by successive pourings of the cool pri-
maries provide you with a color scheme. Don't spatter
a foreign color over the poured area. For example, the
upper right corner of this painting is comprised of yellows,
oranges and maybe a hint of red, so you would spatter dark-
er versions of these colors there. As the background turns
cooler in color, blue can be added to the mix. If a comple-
mentary color is spattered on top, the result is neutralization
or mud.

Q HOW DO YOU KNOW HOW DARK TO SPATTER?

A Go full strength following the value indicated by your
thumbnail sketch. Remember, droplets of water that form
the hard and soft edges on the paper will lighten the value.
Always err on the dark side; it is easier to lighten a color
when the paint is dry than to make it darker by repainting.
Be brave.

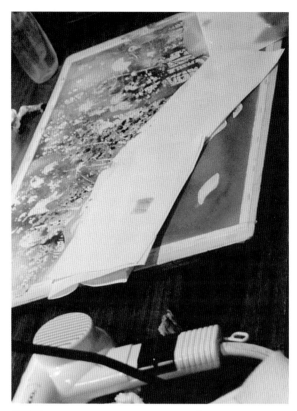

Q WHAT IS THE PAPER TOWEL FOR?

A Layers of paper towel, newspaper or scrap mat board can be used as a shield to prevent thrown paint from getting on the rest of the painting. It doesn't have to be exact, as you can correct it with brushwork.

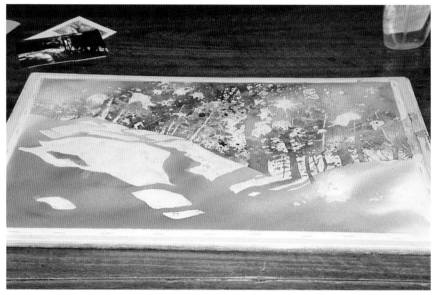

Q HOW DO YOU KNOW WHEN THE SPATTERING IS DONE?

A It is done when the proper texture and value have been reached. Drying and repeated spattering may be required in certain areas. The pouring and spattering complete the initial phase of the painting without the brush ever touching the paper.

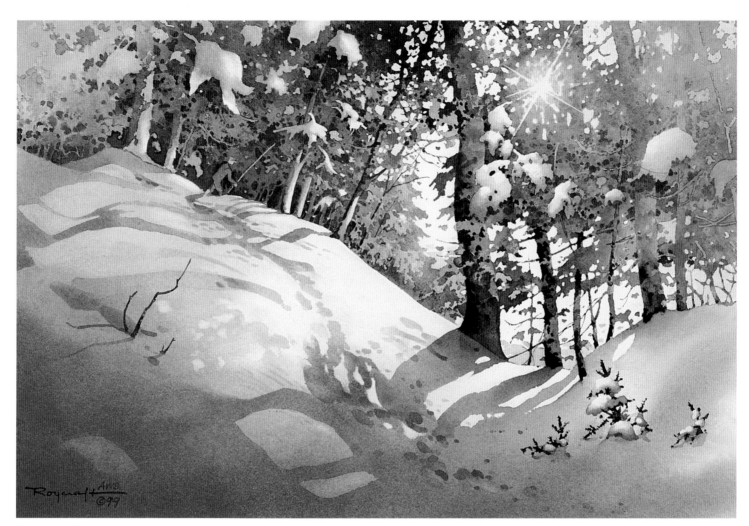

Finished Painting

The masking has been removed and an additional pouring of blue from the lower left has been added to soften the hard edges on the shadows. Using small brushes I added detail to the foreground and added shadows to the large snow clumps on the branches. Final details completed back at my studio define the tracks in the snow of this pristine winter setting.

Winter Tracks

14" x 21" (36cm x 53cm)

Collection of William G. Woodward, M.D.

Common Painting Problems and How to Avoid Them

These three student paintings are very typical of work done before a person takes a workshop. My number-one concern is the lack of a light source in almost every work. Light produces shadows, which are important elements in defining structure. My second observation is the reluctance to make thumbnail sketches to work out the composition and value problems.

I have simplified my critique strategy into three specific areas that prevent students from attaining the level of enjoyment and success they should have. Most immature paintings will fall into one, two or all three of these categories.

Problem 1: Poor Planning

Failing to make a thumbnail or value sketch before starting your painting is the biggest mistake a painter can make. This is the time when the major composition problems are worked out, including determining a light source and the location, size and distribution of the light, medium and dark value areas. Detail is not important, only the major divisions of space. You may have to distort or move some particular element in order to have a proper balance.

I know the excitement of painting overwhelms the dullness of planning, but developing this discipline will improve your paintings more than anything else you can do. There are times when I have made numerous thumbnails of a given subject before finding the one that satisfied me. It also eliminates indecision and serves as a rehearsal to speed up the painting process.

PROBLEM

Poor planning is the basic weakness of this painting. A definite light source producing strong values and shadows would solve the biggest problem. Check the thumbnail I have sketched below to see how it could have been improved.

NO ONE HOME
William Little
15" x 21" (38cm x 53cm)

SOLUTION

I placed the light source at the upper left corner of the thumbnail to create strong light and shadow patterns. The heavy sky brings out the lacework of the snow-laden tree, which now faces into the painting.

For composition purposes the mailbox was moved up and tied into the family of elements with a snow shadow. A smokeless chimney was added to the house to help define the title.

Problem 2: Skimpy Working Materials

It is interesting to walk around the classroom and see the materials the students are working with. The novices will have an assortment of tiny brushes, a palette with no area to mix paint, and a bag full of gadgets that someone told them they should have.

It takes a lot of paint and the biggest brushes you can afford to do a professional job. Also, I make my brushes work for a living. I poke, jab, scrub and squish them to get the effect I am looking for. I don't throw a brush away until there are no hairs left. Each one can make a special mark. By varying the pressure, a brush can be made to do wonderful things. It is not a pencil, but a tool of expression.

Speed is more important than accuracy, especially in applying the first washes. Avoid pickiness and overworking. Only practice eliminates the fear of spoiling a sheet of paper.

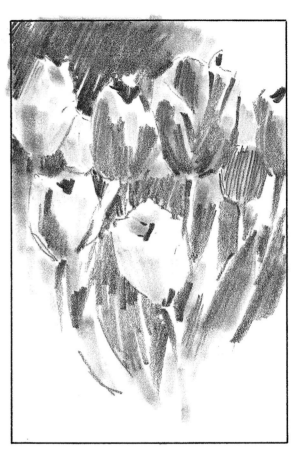

PROBLEM

This painting is weak in all categories due to fear of the medium and improper planning of value patterns. The desire to paint is there, but workshop guidance is necessary to steer the artist's talents. A skimpy palette plus small brushes results in over-worked paintings. Simple, bold washes are usually more effective than several picky ones.

TULIPS
Judy Coats
19" x 15" (48cm x 38cm)

SOLUTION

Simplification is the key to better planning in this painting. This is a case where more is not better with regard to the number of blooms. This thumbnail indicates how a definite light source, located at the upper right, creates a more interesting effect to utilize the light/dark contrast in portraying the tulips. Where the background is light, the flowers are dark. Where the background is dark, the flowers are light. Weak color is the result of inexperience, poor planning and indecision.

Problem 3: Poor Color and Overpainting

I think poor color comes from knowledge rather than perception. People are so used to matching color chips to actual things that they forget that lighting conditions can change colors considerably. We are not in the decorating business; we're in the business of creating an illusion somewhat like a magician. We start out with a two-dimensional piece of paper and are required to give it depth, reality and feeling. In order to do this, we have to lie a little.

We have to study the nature of every color in its pigment form and figure out what illusion is created by associating one color with another. Complementary colors placed side by side intensify each other. When they are on top of each other, however, one deadens the other. I call Winsor Lemon "liquid sunshine" because it gives that feeling wherever it's applied. On the other hand, Cobalt Blue gives the illusion of shadow.

Some colors are transparent, others granular or opaque. There is no better way to learn than by experimenting with them to find out what happens. Keep changing colors as you work, regardless of what you know, in order to keep your paintings from getting monotonous and sterile.

I work with a limited palette based on the three primaries to simplify my painting. Using both cool and warm versions plus the extra blues, I can simulate all the other colors to produce an illusion. I cannot match the actual colors of a certain flower, but I can portray it in a given lighting condition.

Copying photographs leaves your paintings dead because the watercolor pigments don't have a life by themselves. The shiny photo paper bounces light back at the viewer, and that can't be duplicated in a painting. Also, no film is capable of picking up the entire value spectrum. Either the dark areas are filled in or the lights are washed out.

Muddy colors result from overpainting. If color mixing is done in full value on the painting instead of on the palette, you'll never get mud. This why I tilt the board when applying colors; they mix together freely and are pure-looking. If you must overpaint an area, be sure to lift the dried paint below by slightly agitating with a wet brush, and refloat it while applying fresh color to get the value you want. No matter how hard you work on a painting, it should always look like it just happened.

SOLUTION
By lowering the action line and moving the house away from the bird's head, attention is focused on the activities of the two birds. They need to blend somewhat into the countryside and still be prominent. A strong light source at the upper-right corner will give the painting more dimension.

Plan First, Then Let Go!

My philosophy of painting requires thorough planning of composition involving the breakup of space and value patterns. More time is spent at this stage of the painting than in the actual application of paint. The painting stage is where most problems occur if not dealt with first in the planning, the part the artist has control over.

Before picking up your brush, follow these steps to plan your painting:

1. Determine an action line that divides the blank paper into two interesting segments.
2. Drop composition chips to plan the breakup of space, and then decide how you will convert the abstract shapes to realistic ones.
3. Create a thumbnail that provides a value pattern for the finished painting.

Once the planning has been completed with the use of diagramming, composition chips and thumbnails, sketch your subject on watercolor paper in a very detailed manner to locate where the masking will be applied to protect the paper during the wild application of paint to follow.

The application of paint is where the heart, instead of the mind, takes over. Be sure to paint with the heart instead of the mind! This is where the most beautiful stages of transparent watercolor begin. The paint, as it touches droplets of water on the paper, has a life of its own. Your heart will recognize the beautiful results when your mind may not, because it usually will not be what you had in mind. This is the key! I have repeatedly found that accidentals are the best part of a painting.

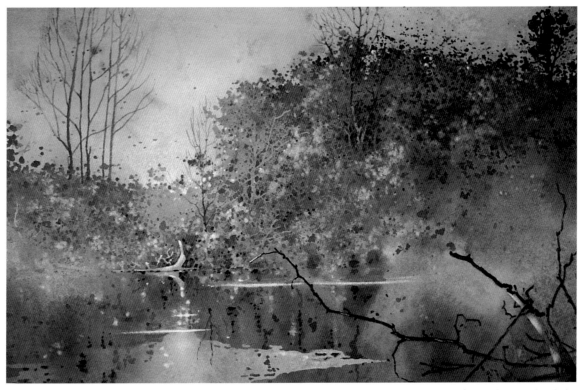

Keep loose at least through the first three-quarters of a painting. If you have the urge to tighten up and follow your mind, do it only at the finish when you're brushing on details. Just don't spoil the freshness you started with.

Remember, it usually takes hundreds of spoiled pieces of paper before these lessons finally sink in. Be not dismayed; we've all been through it.

This painting started as a two-day, half-sheet demo and ended up taking three months to finish. At one point I considered it a throwaway, but I kept coming back to it. I discovered that by matting it to a smaller size, I solved the proportion problem that had been bothering me. The detail in the foliage was lifted and repainted a number of times before I achieved the final appearance. This was a case of perseverance that paid off.

AWESOME AUTUMN
11" x 17" (28cm x 43cm)
Collection of the artist

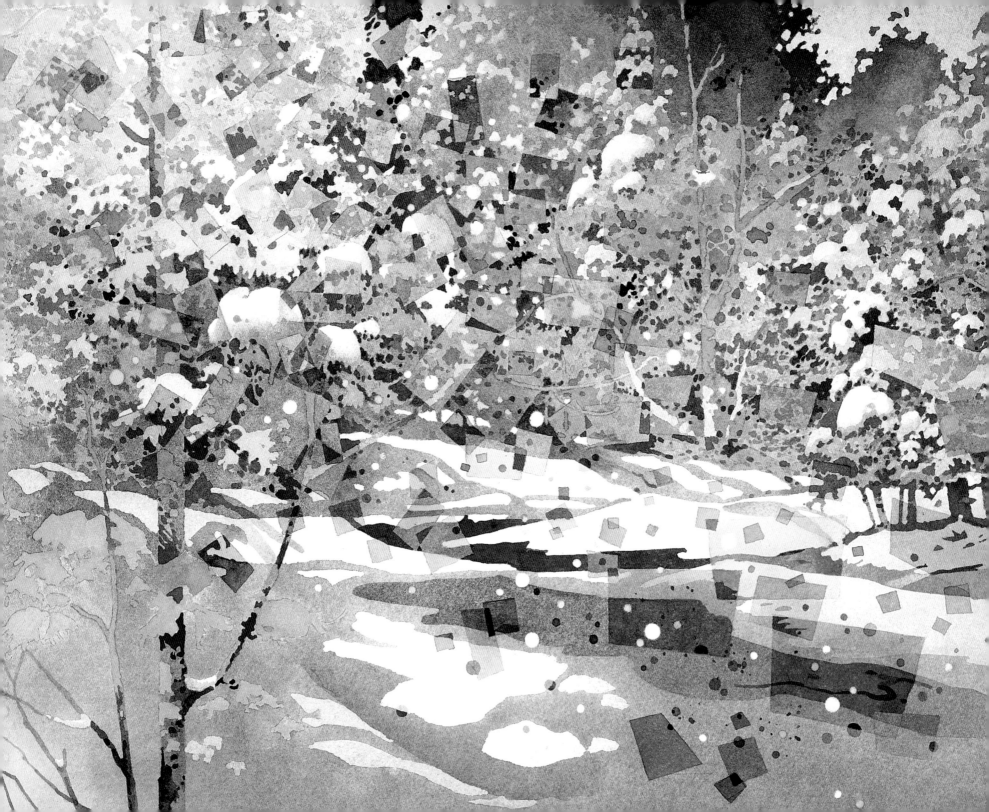

Chapter Six

Enjoy Experimenting
with Watercolor

TRANSFORMATION OF SEASONS
14" x 21" (36cm x 53cm)

Take Advantage of Accidentals

The essence of learning depends on continual experimentation with watercolor because of its fluid nature. It is the only medium that truly has a personality of its own, creating effects independent of the artist. This unpredictability can be either exciting or frustrating; one must keep an open mind. I have found that these unusual happenings are the best part of the painting.

I have a philosophy that in order to paint beyond one's ability or knowledge, we have to rely on the accidentals to help us. Otherwise, we can put down on paper only what we know or have experienced. This is the basis for pouring and thrown paint, or the dropping of composition chips. Stamping, scraping and other indirect methods of paint application also fall into this category. We may hold the brush or tilt the board that holds our watercolor paper, but the fluid paint never ends up the same way twice. This is why we must experiment.

These stamping and scraping exercises can be used to add variety of texture while painting traditionally.

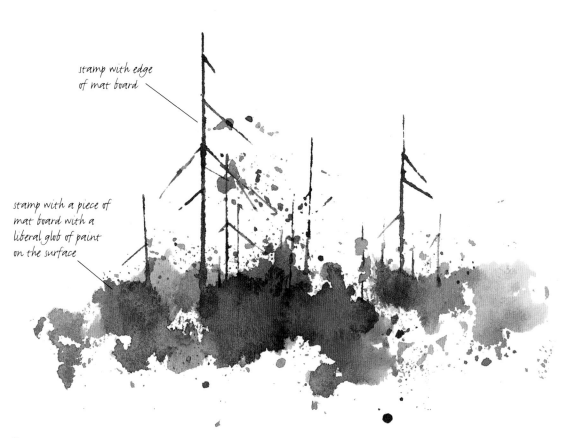

stamp with edge of mat board

stamp with a piece of mat board with a liberal glob of paint on the surface

tip **WORKING WITH A STAMPING DEVICE**

To facilitate stamping, make a handle with tape on the back of a piece of mat board.

STAMPING

This small image was produced by stamping an interesting-shaped horizontal bar of various colors from one side of the paper to the other. Stamping devices can be made from just about anything—for example, crumpled plastic wrap or newspaper dipped into wet pigment on your palette and transferred to the watercolor paper. Also, blobs of color can be painted on chips of mat board and quickly stamped onto the paper. (Masking can also be applied in this same manner.) Use a new stamp for each color change, and let the colors mix on the paper as they overlap while they are wet. The vertical bare trees were stamped with the edge of a piece of mat board. Some spatters were added for variety of texture.

NOVEMBER IMAGE

6" x 8" (15cm x 20cm)

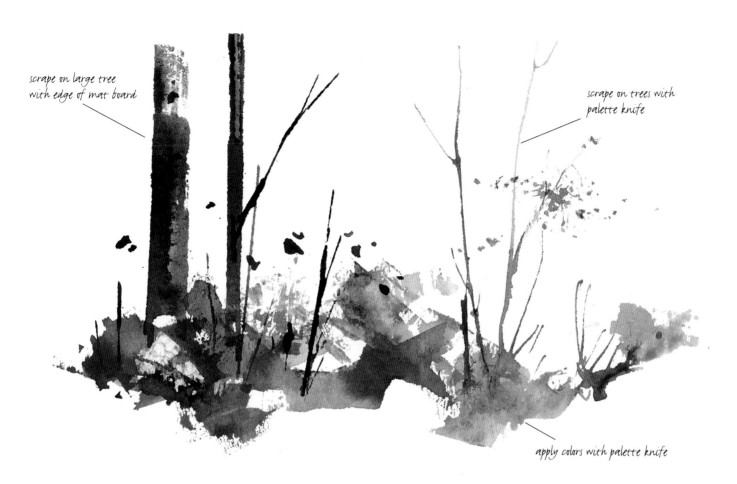

scrape on large tree
with edge of mat board

scrape on trees with
palette knife

apply colors with palette knife

SCRAPING

This time the color is scraped on the paper with a palette knife. Scrape in various shapes and overlap colors on the paper. Dip the point of your blade into the pigment and transfer it to the paper to create the small trees. The large tree on the left was scraped on with the edge of a piece of mat board. Paint can also be scraped out, when wet, with the edge of a dull knife blade.

WILD THINGS
6" x 9" (15cm x 23cm)

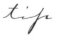 **HOW TO MAKE PAINT STICK TO YOUR PALETTE KNIFE**

If the paint doesn't stick to your palette knife at first, the knife may have to be cured. This is done by soaking the blade in vinegar for a few minutes to remove the shine. Then you should have no trouble picking up the paint.

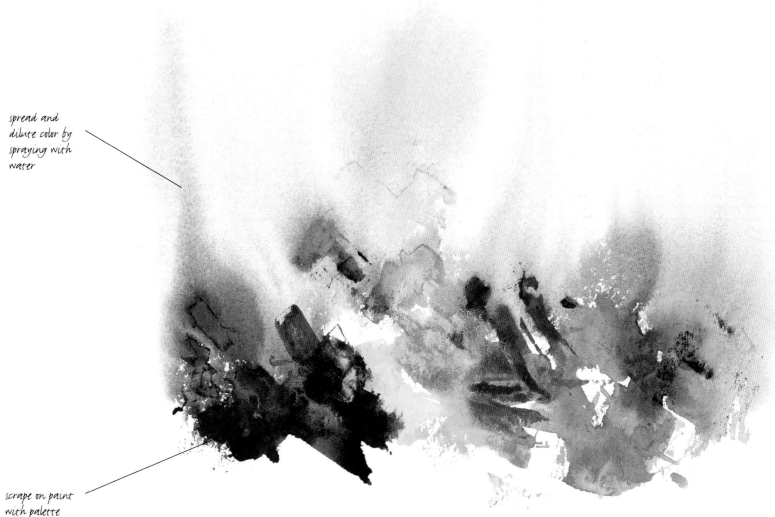

spread and
dilute color by
spraying with
water

scrape on paint
with palette
knife

SCRAPING AND SPRAYING

This example demonstrates one way to produce unexpected results. Try this exercise: Using a palette knife, scrape various shapes and colors in a horizontal pattern. While everything is still wet, tilt the board away from you and spray with water, producing hard and soft edges. Make no attempt to represent anything in particular, but only to discover images that happen by chance.

HIT AND RUN
7" x 9" (18cm x 23cm)

Combine Accidentals for a Painting

This example shows what happens when we combine these three alternate methods of paint application—scraping, stamping and spraying with water—to create a finished painting.

THUMBNAIL

Winter on the Deadstream was inspired by a swampy area near my home that is overrun with tamarack trees and nature's filtering systems. It's a tangle of unidentifiable parts that would be almost impossible to try and copy. To simplify it, all we need to do is analyze the shapes of the three value areas of light, medium and dark as shown in this thumbnail. It's always a good idea to make a value thumbnail before jumping into a new subject. Even if it isn't exact, it will still serve as a guide.

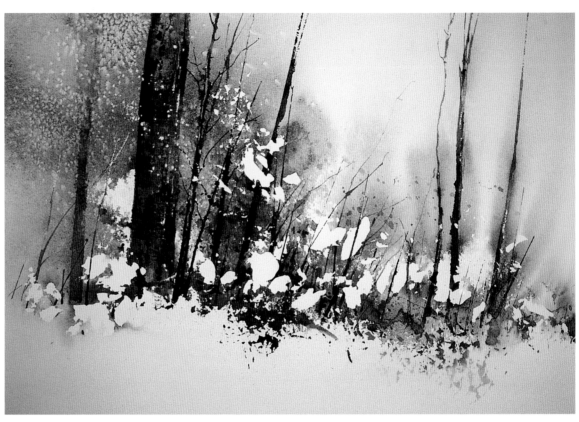

FINISH

By using indirect painting methods, we can paint an entire scene without using a brush. The masking which formed the clumps of snow was stamped on with plastic wrap. The forest floor debris was scraped on with a palette knife. The tree trunks were scraped on with the edge of a piece of mat board. This may not have the sophistication of a serious work, but it expresses feelings and has other qualities that you may not get by just copying a photograph.

WINTER ON THE DEADSTREAM
13" x 17" (33cm x 43cm)

Winter Fire Bush

Now it's time to practice a little indirect painting. The purpose of this exercise is to be free and loose, so we won't sketch any forms on the stretched water-color paper.

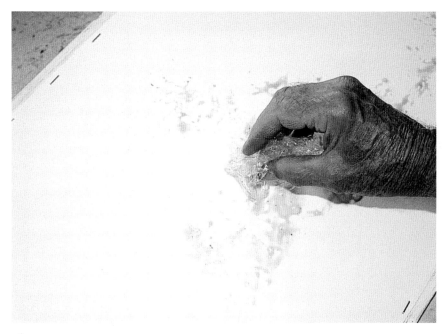

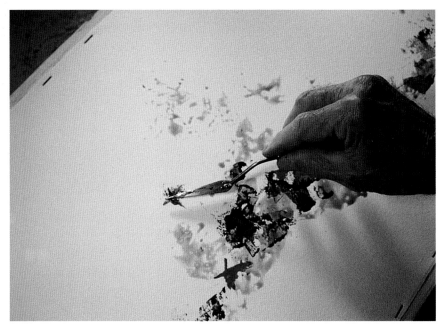

1 WORK WITH MASKING
Pour some liquid masking on a piece of glass or Formica surface. Press a piece of crumpled plastic wrap into the masking and stamp the masking onto the watercolor paper in areas of snow clumps.

2 SCRAPE ON COLORS
Following the bar theory, scrape various juicy colors onto the paper with a palette knife to form the earth section of the painting.

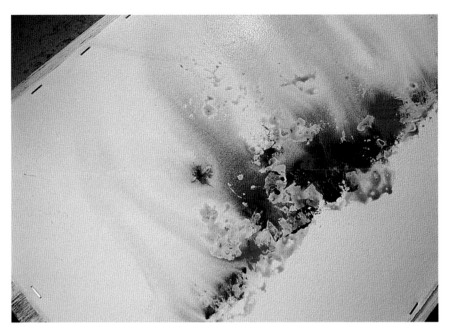

SPRAY WITH WATER

While the paint is still wet, slant the board away from you and spray with water. This finishes the initial stage of the painting, shown at right. Let it dry.

DARKEN SKY AND MAKE SNOWFLAKES

To darken the sky, first rewet the sky area with a spray bottle and then pour on a dark mixture of blues from the upper-left corner. Tilt the board to control the flow of paint, and pour off the excess from the same corner. Sprinkle a little salt to form snowflakes and let it dry before brushing off the salt. Do not blow dry. The salt must be left alone to form the snowflakes.

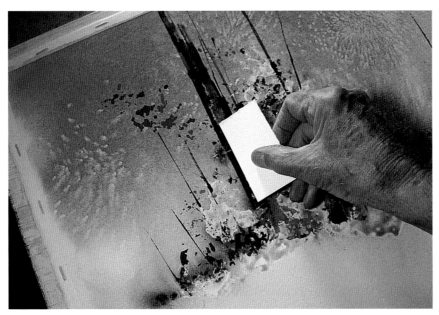

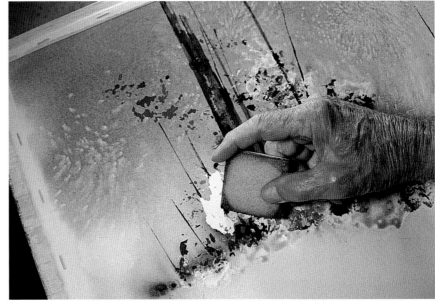

5 MAKE TREE TRUNKS
Form the tree trunks by dipping the edge of a small piece of mat board into dark, wet paint, and then stamp or scrape the edge of the mat board onto the paper. Scraping the mat board sideways forms a larger tree trunk. Let it dry.

6 REMOVE MASKING AND ADD DETAILS
Remove the masking with a rubber cement pick-up and add smaller details with the point of a small palette knife dipped into the paint.

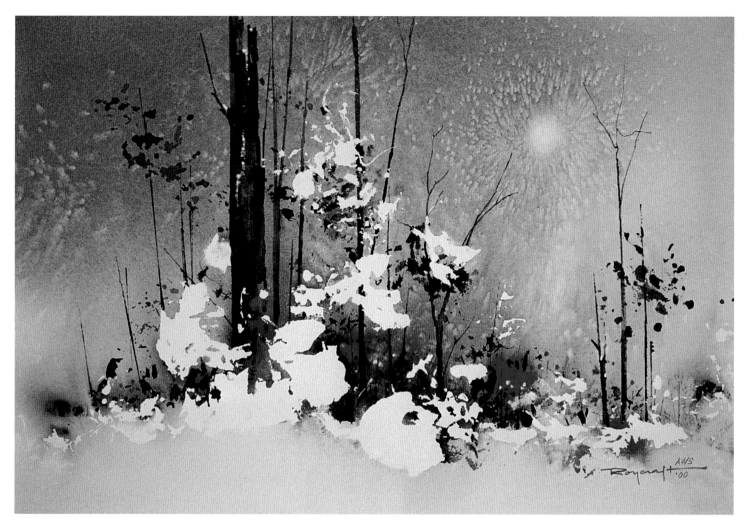

7 FINISH

Add a hazy sun by carefully brushing it out with a damp toothbrush and blotting with a tissue. I had accidentally put too much salt in the place where I ended up scrubbing out the sun, but it was an ideal place to put it. This is how accidents can work for you.

WINTER FIRE BUSH

14" x 21" (36cm x 53cm)

Monoliths Provide Creative Patterns

The spattering, pouring, stamping and scraping of paint are examples of paint application that are not precisely controlled. Another method to experiment with is monolith-making—*mono* meaning "one," and *lith* meaning "a form of lithography." The goal is to stimulate your imagination into creative work instead of copying something that has already been done. We need fresh thoughts and new roads to travel. Whenever I feel that I have gotten into a rut, I try a monolith exercise to break loose.

To make a monolith, follow these steps:

1. Apply heavy blotches of various colors to a hard, smooth surface such as glass or Formica.
2. Firmly press a damp piece of watercolor paper onto the painted surface (or roll with an ink roller).
3. Lift the paper, staple it to a plywood board and let it dry. The transferred image on the paper will be the reverse of the painted surface.

In this method, the colors mix themselves and make an unpredictable pattern. Try making several different impressions, changing colors and patterns. Turn them around or upside down and look for images that remind you of something. It may just be an abstract mood or atmospheric feeling in which an image could be painted. A monolith can produce the starting point for a finished piece.

I save all of my impressions and come back to them later. Chances are I may envision a conclusion that I didn't appreciate the first time around.

The image of each monolith is in the eye of the beholder. Here, I see misty reflections in a pool of water. Pure colors from the tube were painted on the Formica surface. All the mixing happened when the print was made. Salt and a few droplets of water were dropped onto the printed surface to form the natural textures. Everything else is entirely accidental.

REFLECTIVE IMAGE
10" x 14" (25cm x 36cm)

After making the monolith and letting it dry partially, I sprinkled droplets of water on the foreground. This causes backruns—in this case, simulated flowers. After it dried completely, I used an Incredible Nib to further wipe out or magnify the flower forms. Continued wiping out and repainting completed the painting.

SPRING BURSTING ALL OVER
10" x 14" (25cm x 36cm)

After making a monolith with Winsor Lemon and touches of Winsor Red, I sprinkled a little salt on it and stapled it to a board to dry. The pink in the upper-left corner was poured on with Winsor Red. The bare tree on the left was painted with a small brush using Winsor Red and a little Cobalt Blue. Some of the small flowers in the foreground were sharpened by lifting out with an Incredible Nib; a little spattering and spritzing with droplets of water produced others. Sharper edges were scraped out with a razor blade after the paper was completely dry. Finally, the sun was scrubbed out with a damp toothbrush.

MISTY MORNING
10" x 14" (25cm x 36cm)
Collection of Dorothy Roycraft

This monolith evolved into a colorful garden. After the print was made and sprinkled with salt, stronger colors were thrown on in the lower portion of the painting to form a background for the flower heads, which were wiped out with an Incredible Nib. In some places I dampened a blue area with the nib and dropped a little Winsor Lemon on it to turn it green. Each of the flowers were wiped out with the nib and repainted in various warm colors to add variety. Wiping out and repainting is the name of the game. The hazy sun was scrubbed out with a toothbrush. The entire sky resulted from the monolith.

GRANDMA'S GARDEN
10" x 14" (25cm x 36cm)

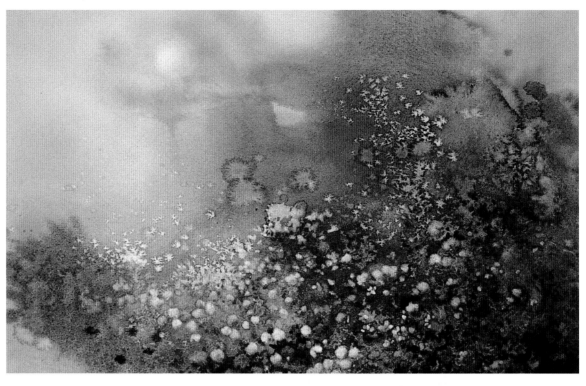

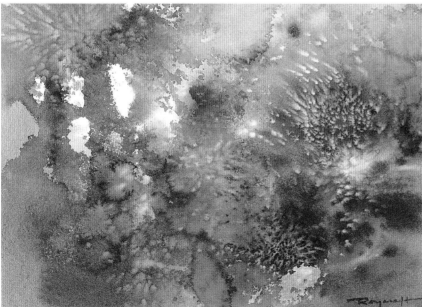

In this monolith I saw vegetation shapes. At first I was tempted to make something real out of it. After long deliberation, I decided to leave it alone. Changes would only destroy the spontaneous feeling that allows each person to read something different into it. Droplets of Winsor Lemon were added to the monolith print in the blue area while it was still wet, forming the green backruns.

FOREST IMAGE
10" x 14" (25cm x 36cm)

Weave Themes in Watercolor

When I first got my computer, I had a dream in which I saw one of my paintings on the monitor. Suddenly, there was a terrific clash of thunder. The screen broke and all the pieces of glass fell on the floor. I got down on my knees to pick them up and put them together again. Obviously, I couldn't get them all in the right place.

As I awoke, I came up with the idea of weaving abstract forms into realistic images. I had been working with the composition chips, so this seemed to be a natural progression. The most interesting thing about the process I noticed after my first painting of this kind was completed: When viewed from a short distance, the painting appears three-dimensional. This results from seeing the representational image through the transparency of the chips.

This painting experiment initially caused some creative shock, but the paintings have grown on me since. They take twice as long to paint because I am painting an abstract form over a realistic one. This involves a lot of negative/positive work. I relate it to music, where a melody and counterpoint are woven together to form a harmonious relationship.

Weaving themes is the greatest learning experience I have found to break the barriers of conception. Because you automatically leave reality, your internal prejudices or control mechanisms are gone. This leaves you free to use colors in places you wouldn't otherwise. It forces you to break conformity and learn something you wouldn't otherwise accept.

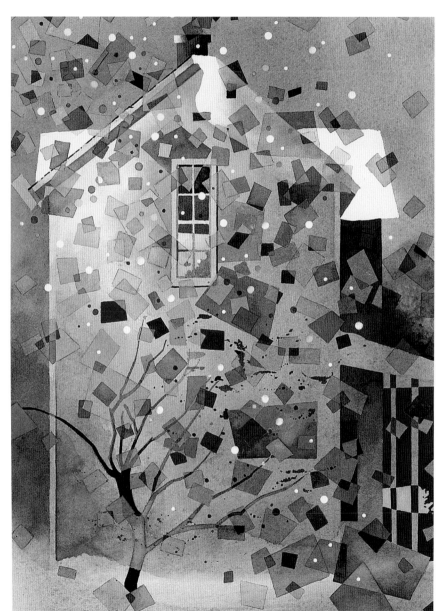

The simplicity of this farmhouse was what attracted me to it in the first place, but it lacked excitement for a painting. First I put a light in the upstairs window to indicate life, and that reminded me of *The Night Before Christmas*. When I added the composition chips, it evolved into the final painting. It's a fun idea, such as a child would dream at that time of year.

HOLIDAY LETTERS FROM ABOVE
21" x 14" (53cm x 36cm)

The "Real" Version

None of my paintings portray the real world as we live in it. I purposely exaggerate the light, color and beauty of a subject, as life is not perfect. In this example, I start with a scene from the Grass River Natural Area in northern Michigan. This is a pristine place where boardwalks have been built so people can traverse these acres upon acres of wetlands to view the wildlife there.

Just being in the presence of nature's wonders stimulates the mind to capture something that a camera can't catch. Benches along the trail invite visitors to sit, close their eyes and dream of how it all began. Such is the life of an artist.

One of Those Rare Days represents my interpretation of this nature trail. Even here I have relied on pouring and throwing paint to form effects that my own ability could not capture. Without being photographic in my painting ability, accidental happenings of poured and thrown paint are the only way I can achieve the illusions of God's masterpiece.

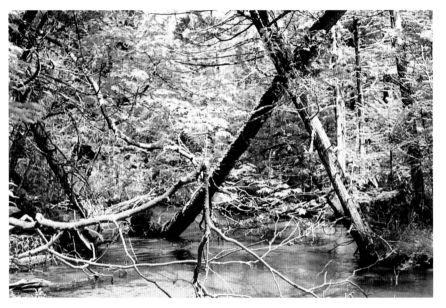

REFERENCE PHOTO
The crossed trees in the Grass River Nature Area captured my attention for the pair of paintings that appear on this page and the next one. They illustrate how a given subject can be interpreted in two different ways.

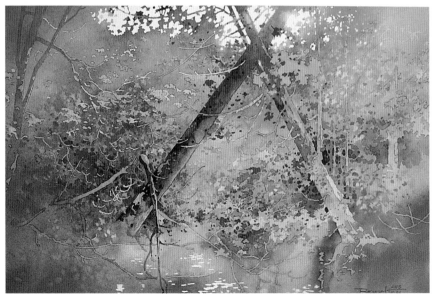

APPROACH #1
The silhouette patterns of the vegetation against the sky and the reflection in the water are the main design features of the painting. The crossed trees give it motion, while the color changes provide variety. Texture plays a very minor role.

ONE OF THOSE RARE DAYS
14" x 21" (36cm x 53cm)
Collection of Marina and Albert Marshall

The Woven Version

This version of the preceding painting is designed to apply to a more contemporary time period where our thoughts travel to outer space. We can only imagine the world of tomorrow. As we play with the real and abstract patterns, we don't know ahead of time what thoughts will result as we comprehend the meaning of these paintings in the future. Such is the destiny of experimental work. I am sure the painters of earlier centuries had the same trepidation as they ventured out of their periods of art.

The weaving version of *One of Those Rare Days* also started with a representational beginning. The values were light enough to allow overpainting of the composition chips. Once I left the real world, I could greatly enhance the colors and drama to create illusions beyond real life. At this point I was being driven by the excitement of color and pattern as they played against each other. It was a game I couldn't put down. I had to see where it was going. This time of creativity is exhilarating and fun to experience.

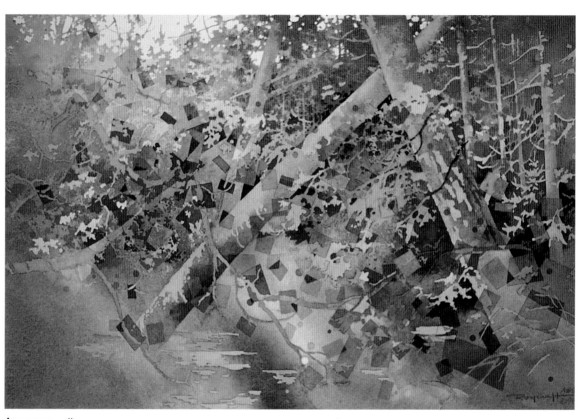

APPROACH #2
The combination of chips with the representational image creates a depth perception that is not possible in *One of Those Rare Days*.

WOVEN IMAGE
14" x 21" (36cm x 53cm)

example
Shattered Dream

This painting started out as an unfinished piece used in a workshop demonstration. As it happens once in a while, it didn't impress me as going anywhere. It sat in my studio for a couple of months until I had my dream of shattered images. After my dream, I dug it out and went to work on this, my first woven painting.

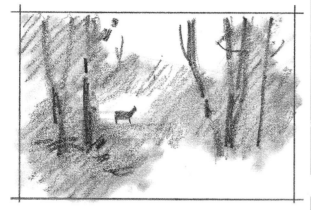

THUMBNAIL
In making my thumbnail, I concentrated on simplifying the shape of the middle-value background. There is a herd of elk near my home, so I inserted one elk as a focal point.

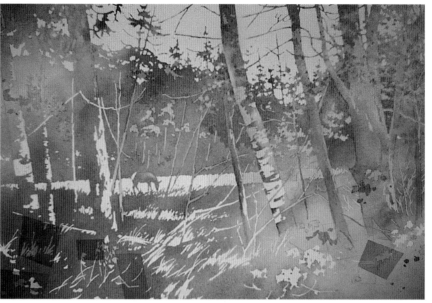

STARTING WITH THE UNFINISHED PAINTING
This was the painting I had put away before my dream. I resurrected it and scrubbed it down with a natural sponge and clean water. (After all, it was only a piece of paper!) I had to lighten the darker portions so I could put another image on top. Then I painted in a few chips to see what the effect would be.

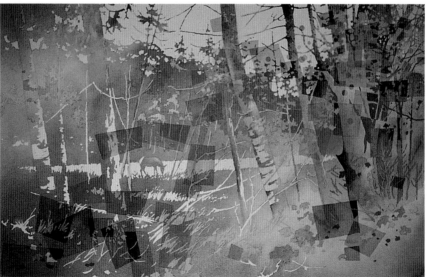

DROPPING MORE COMPOSITION CHIPS
The next step was to drop more composition chips on the painting to lay the groundwork for the abstract pattern that was to be superimposed. When the chips were repositioned to my liking, I traced each chip before removing it. I then painted these abstract images. As we leave reality, it becomes possible to exaggerate the color combinations.

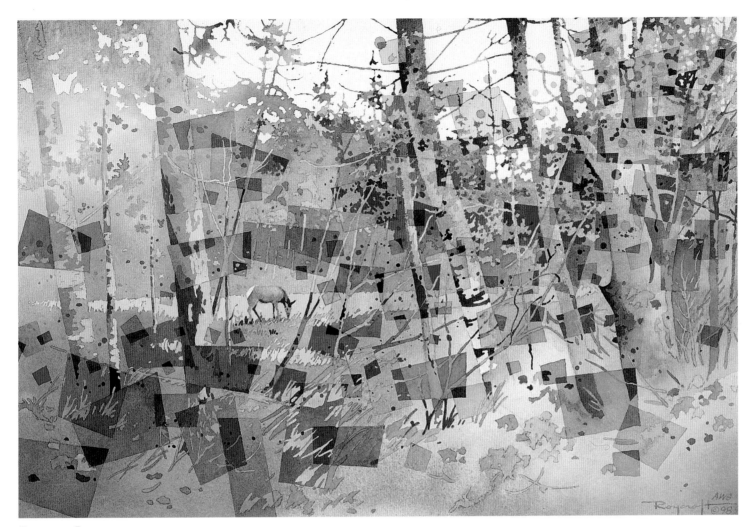

FINISHED PAINTING

More chips were added to emphasize the "shattered" aspect.
Negative/positive images were strengthened to bring out both
the realistic and the abstract, conveying a harmonious relation-
ship. The chips form a window for the grazing elk in the back-
ground.

SHATTERED DREAM

14" x 21" (36cm x 53cm)
Collection of Nancy and By Lyon

example
Hanging Out to Dry

I've had this photo of a front porch for a number of years and could never quite decide how to interpret it beyond the reality of what was there. I'm not one for just copying photos, and the weaving concept seemed like a way of going beyond the obvious. The object of weaving is to reach beyond the everyday world to give deeper meaning to an ordinary scene.

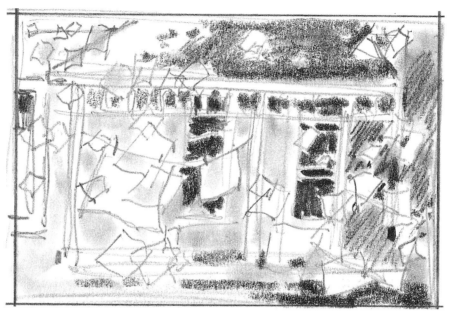

THUMBNAIL
This value thumbnail helps you to envision the conversion using composition chips. The light source is placed at the upper-left corner.

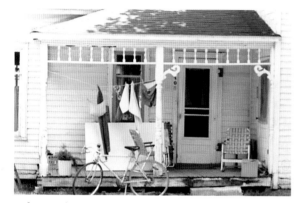

Reference photo

DIAGRAM
This is the pattern for composition chips only. The composition was then enlarged and transferred to a half-sheet of 140-lb. (300gsm) cold-press paper. I dropped and traced the chips next—small ones at the light source, and gradually larger chips as I moved toward the opposite corner.

FINISHED PAINTING

I masked off the sheets and lighted portions of the porch filigree before pouring the three cool primaries of Winsor Lemon, Winsor Red and Cobalt Blue. Masking was lifted, and, starting at the light source, a few chips were randomly tinted so I could get a feel for the subject. I continued to develop the chips plus the house and bicycle following the warmth and coolness formed by the pouring. I added color to everything except the sheets on the clothesline. Some areas were strengthened in color and value to portray the action of the wind drying the clothes.

I wanted the painting to vibrate as a whole. The sheets on the clothesline work in conjunction with the chips to give movement to the composition. The flying chips symbolize objects driven by the wind, such as fallen autumn leaves. The atmosphere is whimsical, and the colors reflect this fun-filled interpretation.

HANGING OUT TO DRY

14" x 21" (36cm x 53cm)

Chapter Seven

A Visit *to* My Gallery

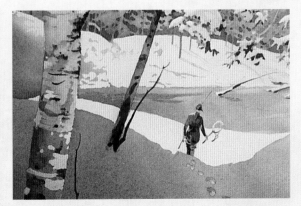

REFLECTIONS
14" x 21" (36cm x 53cm)

The steps leading to a favorite fishing spot on the Betsie River fill up with interesting snow patterns in the winter. I have found that painting any inclined surface is more dramatic if one looks up from the bottom level. The most important task for this painting was building the action line where the background trees meet the sky. The snow clumps on the fence were in one reference photo, and the trees in another. After establishing a light source at the upper right, I proceeded to pour the atmospheric cool primaries to establish the groundwork for the rest of the painting. The sky and snow clumps were masked.

STAIRWAY TO HEAVEN
14" x 21" (36cm x 53cm)
Collection of David G. Mallory, M.D.

Dynamic colors and values are the secret of this fall interpretation. After the initial masking to retain the detail and silhouette patterns, I applied the cool atmospheric colors in a bull's-eye fashion starting with Winsor Lemon at the light source and working outward with Winsor Red and all the blues. The value in the trees and reflections was gradually strengthened to accentuate the bull's-eye feature. The richness of the painting comes from the many layers of paint as the paper, being absorbent, drank up the values as they were applied.

FALL FIESTA
21" x 14" (53cm x 36cm)
Collection of Ann and David Wood

This painting features the sun's glare as it filters through the autumn foliage. These atmospheric effects are fun to paint and can be quite dramatic. I cheated on this one—I was lost about halfway through the painting, so I took a picture of it on a digital camera and enhanced it on my computer. I made a color printout and used it for reference to finish the painting.

AUTUMN GLARE
14" x 21" (36cm x 53cm)

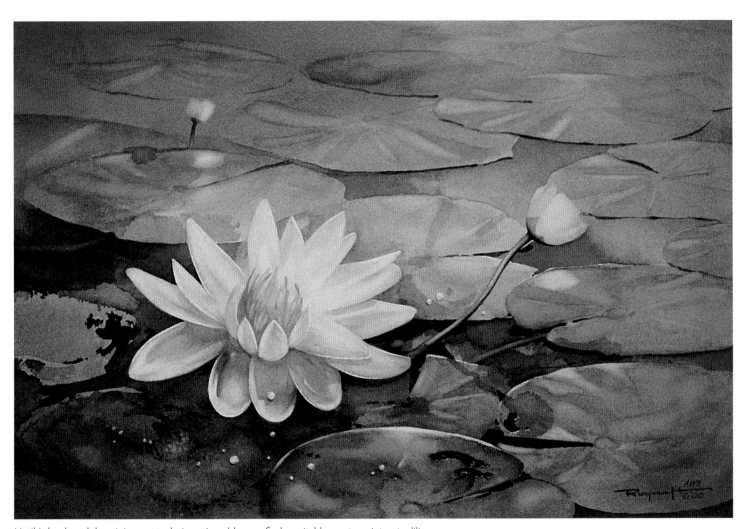

Until I developed the wiping-out technique, I could never find a suitable way to paint water lilies and pads that looked like they were floating in the water. The key is to pour the water first, wipe out the flower next, and then apply Winsor Lemon over the blue water to form the green pads. For the water I used Cobalt Blue in the upper-right corner and Antwerp Blue in the upper-left corner and let them mix on the paper by tilting the board. I poured French Ultramarine and Winsor Red from the lower-left corner and let them flow over the previous applications before draining the excess off the edge of the paper. Details on the lily and pads required additional wiping and repainting. A stencil was cut for the hard edges on the lily. It took three throwaways before I perfected the technique. Patience wins out.

WATER LILIES

14" x 21" (36cm x 53cm)

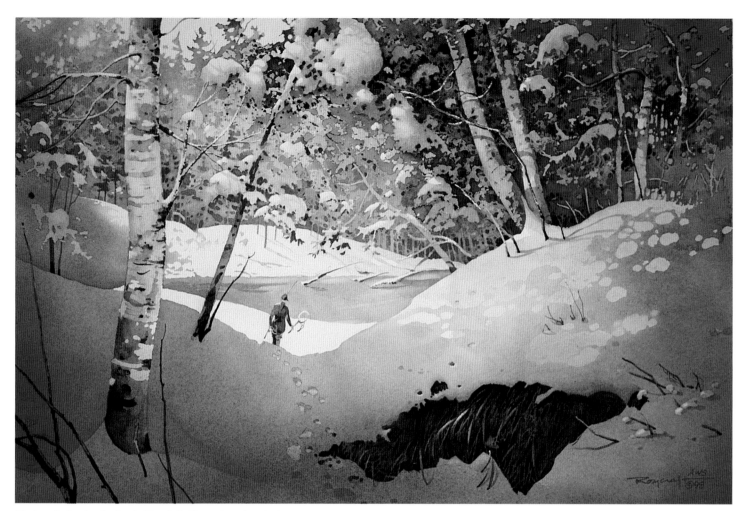

All along its banks, the Betsie River is fed by springs that don't freeze. The river provides great fishing during all seasons. The grassy area in the foreground is one of these springs, and it forms an integral part of this composition of a nice, sunny day. The atmospheric pourings at the beginning of the painting are the secret to its luminosity.

BELOW THE HOMESTEAD DAM
14" x 21" (36cm x 53cm)
Collection of Eugene and Lynn Means

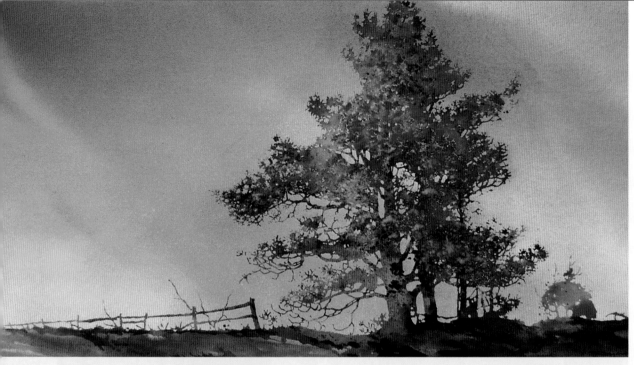

RED SUNSET
15" x 29" (38cm x 74cm)
Collection of James and Eileen Kelly

In conclusion, I want to say that every painting is a learning experience. After a lifetime of commercial art and fine art painting, I have never found a formula for producing a masterpiece. I still have to struggle through every painting, as I never repeat any given one. Consequently, new challenges are always appearing. Therefore, the more I learn, the more I have to struggle.

I do have a tremendous satisfaction in the learning process; it's what keeps life interesting. May the liquid pigments of light create the unpredictable moments of nature that transform the mechanical elements of the artist into spectacular visions of God. Happy painting! ✦

Explore the world of *watercolor painting!*

Using a few brushes, some rice paper and a small number of inks and paints, you can explore new realms of artistic expression in your watercolors. Author and artist Lian Quan Zhen shows you how, providing you with the clear, practical instruction you need to master every element of this intriguing style—from holding a bamboo brush to applying Chinese composition techniques.

1-58180-000-2, HARDCOVER, 144 PAGES

Capture the unmatched beauty of crystal and flowers in your watercolors! Artist Susanna Spann shows you how to "build" your paintings of crystal and flowers like a Polaroid picture, developing them layer by layer, value by value, transforming them into works full of drama and feeling. You'll learn how to produce images of startling melancholy, wondrous joy and everything in between.

1-58180-031-2, HARDCOVER, 128 PAGES

This book provides the painting techniques you need to make the most of every second. You'll begin creating simple finished paintings within sixty minutes, then attack larger and more complex images by breaking them down into a series of "bite-size" one-hour sessions. Twelve step-by-step demos make learning easy and fun!

1-58180-035-5, PAPERBACK, 128 PAGES